Foundation for the Extension...

THE CHALLENGE OF CHANGE

PAPERS AND PRESENTATIONS FROM THE 15th ANNUAL NATIONAL CONFERENCE

Conference Co-Directors
Ruby Lerner, Nello McDaniel,
George Thorn

Edited by Keens Company

FEDAPT

New York

International Standard Book Number:
0-9602942-6-0

Library of Congress Catalog Card Number:
87-071463

© 1987 by FEDAPT

First Edition

Printed in the United States of America

Designed by Pegi Goodman
Goodman Leeds Design

THE CHALLENGE
OF CHANGE

This book was made possible in part by the generous support of the L. J. Skaggs and Mary C. Skaggs Foundation.

CONTENTS

ABOUT FEDAPT

FEDAPT, a national arts support organization, provides organizational assistance to performing artists and their organizations. FEDAPT staff, together with a core of working arts professionals, assists artists in identifying the appropriate structure and resources for the realization of their work. Since its inception twenty years ago, FEDAPT has offered guidance to over five hundred performing arts companies throughout the United States in such areas as organizational structure, staff and board development, long range planning, marketing, fund raising and fiscal management.

Currently FEDAPT's services are: Consortia Programs; Institutional Programs; Theatre/Dance Management Institutes; The Work Papers and other publications; and Regional/National Forums including the Commercial Theatre Institute and Conference.

Other FEDAPT publications are: *In Art We Trust*, compiled and written by Robert W. Crawford; *No Quick Fix (Planning)*, edited by Frederic B. Vogel; *Market The Arts!*, edited by Joseph V. Melillo; and *Investigation Guidelines for Developing and Operating a Not-for-Profit Tax Exempt Resident Theatre*.

For more information on publications or services, contact: FEDAPT, 270 Lafayette, Suite 810, New York, New York 10012, (212) 966-9344.

ACKNOWLEDGMENTS

A conference the size and scale of "The Challenge of Change" and this subsequent record of edited presentations and position papers required a lot of hands, heads, and hearts. On behalf of FEDAPT, I want to acknowledge just some of the people who made a big difference.

First of all, our deepest gratitude to the many speakers who devoted so much time and careful thought to their presentations. This book is a tribute and testimony to the fertile minds and generosity that they brought to the task. Sincere gratitude also goes to our group discussion leaders and to several additional speakers whose contributions were extremely valuable though they could not be included in this publication. They are: Dennis Ferguson-Acosta, Jessica L. Andrews, Anne B. DesRosiers, Danny S. Fruchter, Sarah Kelley, Dan Kirsch, Patricia Lavender, Dianne McIntyre, Jackie Radis, Greg Rowe, Suzanne Sato, and Sheila Wood Konnaris.

I extend my heartfelt love and thanks to my conference co-directors, Ruby Lerner and George Thorn, whose intelligence, vision, sense of humor, and perspective proved so vital to this endeavor. My gratitude also to Frederic B. Vogel and to FEDAPT staff members Christine Ioele, Margery Reifler Dunn, Richard Daniels, Steve Cornwell, Carlyle Smith, Jamie Heck, and interns Rebecca Patterson and Daniel Thompson for their usual grand effort above and beyond the call.

For their extraordinary job in compiling and editing the conference materials, my sincere thanks to William Keens and Bruce Peyton of Keens Company. Thanks also to Pegi Goodman and Goodman Leeds Design for their design work on both the conference materials and this book. We are also grateful to Billie Jean O'Neal for her many hours at the typewriter transcribing the presentations, to Tony Distler, co-director of the Arts Management Institute of Virginia Tech, and to Starr Akers,

Esley Dillon, and Lisa Shaver of the print shop at Virginia Tech, where the book was typeset, printed, and bound.

Finally, our deep appreciation to David Knight and the L. J. Skaggs and Mary C. Skaggs Foundation for their generous help in making this publication possible.

Nello McDaniel
Executive Director

FOREWORD

This book contains twenty-two edited presentations and position papers from FEDAPT's 1986 fifteenth annual national conference, "The Challenge of Change." They are presented here in the same order as they were during the conference itself.

The fourteen FEDAPT national conferences that preceded "The Challenge of Change" dealt largely with the tools and techniques of marketing, fundraising, board development, and planning for arts organizations — topics that were aimed at creating a vocabulary and methodology for an industry that scarcely existed prior to 1965.

In the last few years, however, we began to realize that many of the old tools, concepts, and structures weren't working as they had: Subscription campaigns were less effective, many funding sources were developing new priorities, and the role of the board of trustees was growing more complex and controversial. It became painfully clear that the arts and the larger environment of which they were a part were changing. As creative and clever as the field had been in developing a vocabulary and methodology, we had failed to develop an adaptability that would see us through periods of social, economic, and technological upheaval.

With "The Challenge of Change," we saw an opportunity to explore a wide range of issues and ideas, to pull together the work and thinking that artists and arts organizations had been engaged in individually and collectively, and to hear from experts on such environmental issues as politics, technology, and population. It would also be an opportunity to call upon some of the best thinkers in the arts to offer their views on organizational structures, boards of trustees, arts funding, and audiences.

In preparing our speakers before the conference, we emphasized that we did not want them to deliver sermons from

the mount, complete with ten magic "how-to" tricks designed to solve all problems. Rather, we asked them to use this chance to think expansively and creatively, to pose tough questions, and even to dream a little.

"In dreams begin responsibility," a poet wrote. In the presence of change, we all have an opportunity to rediscover and reinvent the ways in which we approach our craft and then to satisfy the mandate implicit in this act: to shed what we have been, to become what we will be, and to thrive.

INTRODUCTION

BY NELLO MCDANIEL

This is the conference that I've been wanting to attend for a long time. I finally realized that no one else was going to do it, so here we are.

The reason I always wanted to attend a conference like this one is that I hold the record for having learned the rules to the game only to have them changed on me. New rules, new game. Crying "foul" hasn't helped me a bit. And increasingly, it seems to me, the change is faster, more frequent, and more dramatic.

During the last several years, I've been thinking a lot about both the process and product of change. Some might say that I've become obsessed with the matter. If that's true, it's an obsession born out of the frustration of listening to myself advise yet another dance company on how to organize the board or market the subscription campaign, knowing deep down that there was little chance their efforts would be rewarded. The old tried-and-true methods just weren't producing results, and I didn't understand why.

My frustration also springs from working in an industry based on vision, innovation, and imagination that has nonetheless been slow, unimaginative, and clumsy in dealing with an ever-changing world. Our tendency has been to react to events without understanding their complexities and to do virtually nothing that would enable us to foresee and affect events in the future. Our present is our past, and we view the future as an endless succession of tomorrows that look approximately like today.

Recent history shows us that such linear, two-dimensional thinking is usually far off target. Ten years ago, in 1976, Watergate had just crested and both Richard Nixon and the Republican party seemed vanquished for a very long time. Had anyone suggested in 1976 that Ronald Reagan would be President, ever,

I would have laughed. But here we are in 1986, Reagan has been President for six of the last ten years, and Nixon's back playing the role of elder statesman.

There was also no reason to believe in 1976 that the budget of the National Endowment for the Arts (NEA) would do anything but continue to grow, with periodic leaps forward. Had the NEA's budget grown at the same rate from 1977 to 1987 as it did from 1967 to 1977, it would now be roughly $1 *billion*. Instead, it is little more than what it was when Reagan took office.

Of course, while time can play some strange and sometimes cruel jokes on us, numerous positive things can also occur. During the same period that the NEA's budget lost ground, for example, the state arts agencies around the country generally gained ground, while local arts agencies—virtually unheard of ten years ago—have become a rapidly expanding force in the arts arena.

At any given time there is always greater continuity than there is change. But change is a fundamental and essential ingredient in continuity. It's not our intention during this conference to place change in a cleanly understood and rational context or to suggest that all change can be controlled. This would be impossible. Rather, we hope to achieve more modest but still very valuable results, and we have based this conference on several fundamental tenets regarding the matter of change:

1) At any given time, we are all both the beneficiaries and the victims of change. To some degree we can control the extent to which we benefit or are victimized.
2) For each of us, there is an appropriate response to the changing environment, and if that response is active and informed instead of passive, all the better.
3) We must not be seduced by the quick fix or easy answer. Isolated trends—whether mini- or mega-trends—can be misleading. The process of thinking—of analyzing, synthesizing, understanding, and projecting—is at least as important as the products of change. And the process never ends.
4) Nothing is gained by feeling threatened, fearful, or defensive about change, or by pretending that it's not an integral part of our environment. When it comes to change, a good offense truly will be the best defense.
5) Effecting or making change requires a certain leap of faith and thinking. We can't be half-hearted; to embrace

the new we must let go of the old. The new paradigm or order will not be "figured out," but suddenly seen and realized.

6) Even a small group of people with strong beliefs and values are capable of bringing about profound changes in the workplace, marketplace, and society in general.

According to Patricia Aberdeen and John Naisbitt in their book *Re-Inventing the Corporation*, change is usually effected by one of two driving forces, and ultimately both must be in place before real change occurs. These forces are economic necessity and new or altered values. They are an interesting combo and can be key barometers in observing the flow and nature of change.

For example, when the gasoline shortage of the mid-seventies hit, Detroit went into an economic tailspin. The necessity of dealing with the gas shortage motivated the American auto industry to start making smaller, more fuel efficient cars. Suddenly, Detroit became the world's "small car experts," as the ads stated. But now the gas shortage has become a gas glut, and, lo and behold, big cars are back on the show room floors and in the ads. In this case, the American auto industry's change to small, fuel efficient cars was a temporary accomodation of "certain market aberrations." Altered values did not accompany the economic need, despite the fact that nearly everyone acknowledges that the gas shortages will return.

On the other hand, when the women's movement started getting attention in the early 70s, it was viewed by many as a small group of radicals making noise about a cause during a time when that was what most people did. Well, the women's movement was and is considerably more than that, for in less than twenty years it has altered nearly every aspect of our society. Today, women are such a powerful presence in the work force and marketplace that business and women's roles in society will never again be what they were before the women's movement.

In the arts business, money may not *motivate* us, but we are constantly aware of our economic needs, which affect us a great deal. How we respond to economic necessity is value-laden indeed. How we respond can make a big difference to our work, our organizations, and the society we hope to improve and change through them both.

Unlike previous years, this FEDAPT conference is not about technical assistance. You are not going to learn ten nifty new

techniques for increasing this year's subscriptions. You will not be carrying pounds and pounds of paper back home for your files. However, you will be hearing a wide range of speakers—artists, managers, funders, public officials, social and political scientists, authors, futurists, and religious leaders—offering some very personal points of view with regard to the changes that are upon us and the opportunities and dangers that may lie ahead. And although your paper files may not expand because of this conference, we hope that your mental files will.

During these next three days, we are going to examine both the process and products of change and the complex set of cause-and-effect relationships that are part of it. It's my hope that we will also begin to develop new ways of viewing the world and our place in it: not only how we can better understand the nature of change, but also how we can effect change that is more favorable to our interests.

BY GEORGE THORN

For me, the roots of this conference go back several years, when Jessica Andrews, Nello McDaniel, and I came to the realization that most arts organizations were experiencing a great deal of stress. The most obvious symptoms were increasing shortfalls in earned and contributed income. Subscriptions were either falling behind or being maintained at an ever-increasing human and financial cost, while deficits were being incurred for the first time or existing debt was being increased.

The stress was producing tension among the artistic, board, and management leadership. People were resigning or being fired. Marketing and fundraising departments were being pushed to meet higher and higher goals. Telemarketing and tele-fundraising were peaking. Everyone was looking for the next quick fix.

As the three of us and others began to evaluate what was going on, it became apparent that the problems ran very deep. We began to realize that the environment of the past twenty-five years or so—which had encouraged the growth and proliferation of arts organizations—had changed. What's more, it was continuing to change at an ever-increasing rate.

Among the factors with which organizations had to contend were these:

1) Our national priorities were shifting.
2) The giving priorities of funding agencies, corporations, and individuals were changing as a result.

3) The recession was taking its toll.

4) The expansion of arts organizations and events had created many more choices for audiences.

5) Competition for our leisure time had grown intense, especially with the introduction of the VCR.

As an example of how our environment was changing, let's look at just one area: subscription campaigns. With so many more leisure-time choices available to people, they began to resist the escalating cost of subscriptions. Working couples— who may not even know whether they can have dinner together— were being asked to commit a year in advance to attend the fifth event on the third Thursday in April. The result was that people became event-goers, not institution-goers.

As the competition for audiences intensified, arts organizations placed more emphasis on direct mail and telemarketing. Many of them had come to count on continuing growth in subscriptions and earned income, and their marketing budgets and staffs needed to grow just to stay even. Furthermore, at a time when people wanted a stronger sense of personal involvement with the arts, the demands of mass marketing tended to make an organization's relationship with audiences more impersonal.

One of the most difficult experiences for many organizations was the fall-off in growth. After all, growth had long been considered the universal standard of success: Is your budget growing? Is your subscription base expanding? How many new and innovative programs are you adding? How many more artists are you hiring? Is the number of performance weeks expanding? These pressures, and others, were being generated both internally and externally.

What became clear was that business as usual would no longer succeed. Every organization found that it needed to research, test, and rethink what it was doing. One more mailing or tele-fundraising wouldn't solve the problem; there would be no quick fixes. Even the largest and most well-endowed institutions discovered that they were not immune from the pressures of change.

So here we are, propelled by forces that we are just beginning to understand, struggling with transition, and of necessity becoming more involved with the world around us. Out of all this and much more, this conference has been formed.

We all know that we can either be part of change or be left behind, but our response to change doesn't always reflect this

knowledge. In my experience, people tend to react to change in one of four ways:

1) They ignore it, insisting that everything is fine, and business goes on as usual.
2) They know that things aren't just right, but all they do is talk about their sense of misgiving.
3) They become Chicken Littles, expending enormous energy prophesying doom and doing nothing else.
4) They see change as an opportunity, and they develop ways of thinking and responding that aggressively and creatively challenge or embrace it.

Encouraging the latter—making it possible to affect and lead change—is what this conference is all about.

Obviously the arts are not the only enterprise experiencing the stress of change. I have read that 250,000 people will never again work in the automobile industry in this country; that 150,000 are gone from the steel industry; and that the picture is similar in energy, agriculture, and other industries. So we're not alone. Many sectors of our society have been unable to anticipate, or been afraid to embrace, change.

Of course we can all understand the dilemma that change presents. Think of the pace! It took about ten years for the calculator to evolve from the large desktop model to the inexpensive pocket version that we now have. But given our current technology, such a change would only take one year today.

And just consider what would have happened if the Iceland summit agreement had been struck: What a profound change would occur if nuclear weapons were phased out, completely altering the way the world has functioned for the past forty years. The idea that nuclear disarmament might destabilize the world only adds to our bewilderment, as does having to rethink concepts of conventional weaponry and warfare. The ramifications are staggering. Is it any wonder that we often feel confused, threatened, and overwhelmed?

I was recently introduced to a book that I strongly recommend, *The Aquarian Conspiracy* by Marilyn Ferguson. In discussing personal and social transformation, she describes four basic ways in which we change our minds whenever we get new or conflicting information.

First is what she calls change by exception. Our old beliefs remain intact but allow for a handful of anomalies, the way an old pattern tolerates odd phenomena around the edges before becoming a larger and more satisfying configuration. An

individual who engages in change by exception may dislike all members of a group except one or two, who are accordingly regarded as "the exceptions that prove the rule."

Second is incremental change. This occurs bit by bit, and the individual is often unaware that change has occurred.

Third is pendulum change, the abandonment of one closed system for another. Pendulum change fails to integrate what was right with the old and fails to distinguish between the value of the new and its overstatements. Individuals engaged in pendulum change reject their own prior experience as they swing from one state of half-knowing to another.

Ferguson calls the fourth kind of change paradigm change-transformation. Motivated by a new perspective, by insight that allows information to come together in a new form or structure, paradigm change-transformation refines and integrates. It attempts to heal the dichotomy of either/or, of this-or-that. We realize that our previous views were only part of the complete picture—and that what we know now is only part of what we'll know later. Change no longer seems threatening; instead, it absorbs, enlarges, enriches. Each new insight widens the road ahead of us, making the next stage of travel that much easier.

I believe that we in the arts have a very special resource that encourages paradigm change-transformation: It's the creative process itself, our familiarity with collaborative approaches to problem-solving, and our flexibility. What we need now is to summon all the creativity that our organizations possess and to apply it not only to our artistic work, but also to our management and planning as well. We must recognize that, as artists and arts administrators, we are engaged in guerilla activity. Our organizations survive by living off the land, making use of limited resources, responding quickly when opportunity arises, and creating our own opportunities. Given this readiness, these resources, we should be seeking change, not just accepting it.

By what criteria, then, will this conference be considered a success? Let me close by suggesting a few guidelines:

1) If, throughout the conference, participants remain open to the ideas discussed and recognize them as sometimes personal and theoretical explorations.

2) If we better understand how our environment has changed and what the future might hold.

3) If we become more aware of the world around us, more externally focused.

4) If we recognize that fast-paced change is both a fact of life now and an opportunity.
5) If we begin to ask questions about and see our organizations and our work in new ways, and in the process begin challenging old assumptions.
6) If we begin to develop ways of thinking and planning that challenge or embrace change creatively and aggressively.

Thank you very much.

PART I

THE ARTS
ENVIRONMENT

BY RICHARD LOUV

CHOOSING AMERICA

What I am about to say may be a little uncomfortable to some of you because it's about the fading away of something that you and I hold very dear: the central city. We are indeed in the midst of a major population shift out of the old cities, a phenomenon which I refer to in my book *America II* as the deconcentration of America.

In researching the book, I visited many of the places to which people are moving in order to ask them why. Everyone seemed to speak with one voice. They described what they were looking for as a sense of home, a place where they could feel safe and secure, a place where their kids could go out on Halloween and not find pins in their candy. They were searching for something they felt they'd lost, something they probably never had.

Although our senior citizens began this movement in the 1970s, the Baby Boomers are the ones who are now moving the fastest and in the greatest numbers. In the sixties, "home" was the last place they wanted to be. Instead of the suburbs, they wanted Soho; they wanted something wild and unexpected, perhaps even a little dangerous. They got over that pretty quickly when the economy started to slide; that simple house in the suburbs began to look awfully good once it was no longer so easily attainable. Now, unable to go home again, the Baby Boom

generation is searching for some fresh place, a place that stands for something lost.

In the process of this search—and for a number of technological and economic reasons—America is deconcentrating, changing from a densely centered manufacturing-oriented society to a dispersed service-oriented society. This is not a return to the old suburbs, many of which have died right along with the central cities. The new suburbs are further away from the urban core, and they are not just bedroom communities. The old type of zoning, which had everybody living here—in the 'burbs—and working there—downtown—is for the most part giving way to "mixed-use" zoning; in the new suburbs, people work closer to home, or at least have that option.

Many people are moving even further than the new suburbs. During the 1970s, rural America posted greater population gains than the nation's metropolitan areas—the first time that had happened since 1840. But just as the suburbs are changing, rural areas, too, are becoming something quite new. The tenth most populous state in the nation is North Carolina, which is amazing when you consider that North Carolina has no really large cities. What it has are vast "invisible" cities. You can't see them close up. You have to look at them from pretty far away to understand that they truly are metropolitan areas. But although the people who live in them travel longer distances than urbanites and suburbanites, their new "homes" provide them with places to live and work, and very few of them make their living farming. This is true throughout rural America. As farms give way to a new kind of economy, we see the rise of what some have called "buckshot urbanization."

There are now two kinds of cities: the "America I" city and the "America II" city. Philadelphia, Cleveland, St. Louis—these are the old industrial cities of America I, with their huge downtowns and bedroom community suburbs. The population of America I is shrinking. In recent decades, New York City has lost as many people as it would take to populate San Diego, which is now the seventh largest city in the nation. St. Louis lost around one-third of its population in the 1970s; it's back to where it was in the mid-1800s. The cities of America II— Houston, San Diego, and Orange County, which I consider a city unto itself—lack strong downtowns, and population tends to group into what demographers call clusters and nodes, sprawling, booming blobs dominated by strip developments and freeways. But population is growing, steadily and rapidly.

Ultimately, the environment in these newer cities is alienating, but trying to force them into the old America-I mold is just not going to work. The people who have moved to them have voted with their feet against centralized, high-density urban places, and this is the trend all over the developed world. Yes, people are moving back into the central cities and gentrifying them, but the numbers don't compare with what is going on elsewhere. Ironically, the "buckshot cities," beneficiaries of the major population shift, are difficult to see, whereas the gentrified central cities, even with their net losses in population, are highly visible. This is because we know where to look and what to look for in the central city. We recognize the signs and symbols of urban vitality and renewal from our cultural traditions, and this creates an illusion that the central cities are coming back. They are coming back aesthetically, but not in terms of population.

Many of the clusters and nodes into which the population of America II is forming are completely self-sufficient, planned communities, and for the first time in our history, municipal and county governments and all the other traditional forms of local government have a serious competitor for the provision of services. Instead of land, millions of us are buying air space in condominium buildings, or snapping up single-family dwellings in communities run very much like condos, with covenants and rules and regulations and a kind of private zoning. We can't plant a rose bush or change the color of our curtain liners without the approval of private mini-governments, which now outnumber all other forms of local government combined. With the private taxes they gather—heading toward ten billion dollars a year—community associations are buying everything from private cops to sanitation services to entertainment to communal computers.

The most important marketing tool in these communities is security. The "Leave It to Beaver" tract house was sold with the fully-electric kitchen. The new shelter in America II is sold with full electronic surveillance. A high-rise condo in La Jolla even has its own private bomb shelter. Orange County's Leisure World is surrounded by six-foot walls topped with two-foot-high bands of barbed wire. At Towers of Quayside, a condo community in Miami, the central computer security command post has walls of video monitors hooked up to cameras on the racquetball courts, in the jacuzzi rooms, and in all the hallways. The security staff can even turn on the television set

of a specific resident and issue a message, whether or not the resident wants to hear it.

There are important public policy, political, and legal issues here. If a condo community has its own private cops, its own private entertainment, its own services, why should it care if the city across the river has no cops, no services, no arts? In most states it is unclear whether community associations are businesses or governments. In actuality, they're both. But insofar as they are judged to be businesses, the personal freedoms guaranteed by the Constitution do not necessarily apply. Certainly, these mini-governments have more power than we have ever granted to traditional forms of government, but in researching my book, I found only one political scientist in the country who had made a serious study of this completely new form of local government. He felt that what America is witnessing is the birth of a strange governmental hybrid for which he can find no other corollary, a kind of democratic socialism based on communal property rights.

I suggest that as deconcentration continues and as new forms of housing and government and community develop and mature, there is great opportunity to be seized by artists in describing this society to itself. Just as few political scientists are looking at this new America, so, too, few artists are attempting to illuminate it. My sense is that America II yearns for the illumination and humanization that only the arts can provide and for which its citizens will eventually pay money.

One of the most prominent forms in America II is the new downtown, the shopping mall. In the fifties and sixties, malls were rather sterile in design and organization. The idea was to keep the customer moving from store to store, so benches were taken out of public areas, and few amenities were provided. In the 1980s, the idea is to keep the customer inside the mall for as long as possible, so the benches have been restored and many new amenities are being introduced, along with all kinds of special events and activities. What we have now is the "festival mall." (Sterility is still alive and well, however. Last Christmas, several New York malls banned the Salvation Army's bell ringers because they distracted the shoppers.) The next trend will be toward non-retail tenants—bingo parlors, day-care centers, doctors' offices, aerobic dance studios, television stations, and even residential housing. The mall of the future will be part circus, part village, part consumer theme park, with more trees, more waterfalls, live bands, jugglers, food fairs, and street

vendors—all to attract the new clientele, who are ready, it seems, for the unexpected, for a kind of organized, packaged surprise.

Again, there is a role here for the arts. It's going to be tough because, like condo communities, malls are essentially private. But more political pressure should be brought to bear to make them public, to make it okay to hand out leaflets, to hold public events and performances, to do all the things that, in the past, gave life and liveliness to America's main streets. If the malls truly are the new downtowns, then they need to be opened up to the spontaneity and genuine surprises that the old downtowns offered. Otherwise, we're headed for an increasingly sterile society.

To paraphrase Winston Churchill, we shape our buildings and thereafter they shape us. The same is true for cities, malls, condos, planned communities, and "buckshot cities." Sooner or later, when the economic edge begins to dull in some of these fresh new environments, people will look around and begin to realize that something is missing, that they may not have found what they came here for: a sense of home. At that point they will begin to make different kinds of decisions. Either they will move back to Pittsburgh or Cleveland or New York, or they will begin to reshape America II into something more satisfying, less alienating, more like home.

In the "America III" that I see, planned communities don't have to be as sterile as many developers have made them. Village Homes, outside Davis, California, is really a kind of flip side to the typical planned community. Rather than having rules forbidding the planting of gardens, home gardening is encouraged. The houses—which are not identical—face a central courtyard, and there are bike paths and walking paths throughout the acreage. Whereas many of the America II communities are quite "anti-child," Village Homes sponsors numerous activities for children. Instead of a wall around the community, it is surrounded by an orchard of almond and pecan trees, and children are paid by the community association to harvest the nuts and sell them in a kind of farmers' market in the middle of the development.

Another example of America III is what is happening in Phoenix, Arizona. Aware that sooner or later people are bound to look around at the ex-urban sprawl surrounding them and decide they don't want it, Phoenix planners and government officials are formalizing what has so far been a helter-skelter movement into clusters and nodes. These are being organized

into urban villages, each with its own downtown. These separate downtowns will determine their own character, but they will be essentially *public* spaces, providing more opportunities for public arts, street life, and the unexpected than the developers of *private* communities usually allow.

Children are essential to America III. Many cities have only recently realized that they have been short-sighted in this regard in the past. Among some urban economists, the theory has been that single yuppies were much better for cities than families with children. Yuppies don't need schools, don't care about services; all they want are good restaurants. But kids are the future. If a city treats its children well, they'll treat the city well later on.

America II may well be more of a crossroads than a destination. At this crossroads we have not two but three directions to choose from. The first road is behind us—the fading America of smokestacks and giant metropolises. The second is the one that much of America is on right now. It leads toward organized units that enforce social sameness, commercialized nostalgia, and a perversion of traditional democratic values, toward an America of walled enclaves, disposable friends, over-organization, and a kind of technological security that gives a false sense of protection while increasing our society's disruption. Down that road are private services for those who can afford them and not much at all for those who cannot. Down the third road, which is poorly marked, are similarly dispersed cities and a new countryside, but within the new communities there is an intensified sense of responsibility, the realization that the further society disperses physically, the more we need human connections.

Down this road, too, lies great opportunity for the arts— to humanize what now feels so sterile and deadly, to illuminate America II and light the way to America III, where, instead of destroying what we seek to enjoy, we will accept our stewardship of the land and our responsibilities to each other. At the end of this road, which leads not so much "out there" as inside ourselves, we may find what we have sought all along. We may find home.

BY THOMAS P. CARNEY

FROM
A
SCIENTIFIC
PERSPECTIVE

Ordinarily when a scientist is asked to talk about the future, he talks about the spectacular things. I suppose the most spectacular scientific event that has occurred in our century was the moon landing. I can still remember the thrill of watching it on television, the sense of national pride, and of technical pride in what we could do. But it didn't affect my life one bit. It was very spectacular, but it was there and gone, and I'm the same as I was before.

If the spectacular things don't really change our lives, what kinds of things do? Certainly medical research does, and in this century I suppose the two greatest medical advances have been the development of steroids and anti-infective drugs. In the future, however, a field that we are now only beginning to open up will, I think, outshine either of those—not just in medicine but in agriculture and industry as well. This new field is biotechnology, which will allow us to work with genes, to identify and isolate them, to synthesize them, and, more important, to replace them. An antibiotic kills bugs after they get into your system; it cures diseases. Steroids can affect some of the activities of different organs of the body. But with genes, the organs themselves can actually be changed.

One of the obvious targets of gene work will be diseases caused by genetic defects. Each year there are 250,000 babies born with

some kind of birth defect. Twenty percent of those defects are totally genetic in character, and an additional sixty percent are both genetic and environmental. Think of what we will be able to accomplish by replacing or influencing the genes that are wholly or partly responsible for eighty percent of the birth defects in this country.

Genes can also be transferred in other life forms. For example, by identifying the gene responsible for producing a certain drug or chemical and finding an organism that can use that gene, we can make the organism produce the drug for us. This has been done in a number of cases with bacteria, which we grow in tanks, at the proper time isolating the drug we want from the bacterium's metabolic product. In synthesizing drugs and chemicals, bacteria substitute for factories. Human insulin produced in this manner is already on the market, along with at least four other drugs, and twenty-five more are in clinical trial.

Biotechnology also promises to be helpful in animal husbandry. Because genes influence various characteristics of living things, if we want to produce an animal that has leaner meat and greater weight, we simply find the right gene and express it into the animal, and the animal will have the characteristics we want. To do this now requires selective breeding over years and years. But in the future, with genetic engineering, we'll be able to do this overnight, and when the animal reproduces, the new characteristics will continue in the next generation.

Every advance in science has two sides, of course, but these days we seem to look only for the bad side. When was the last time you read a newspaper report that made reference to a chemical without calling it a "toxic" chemical? Technically this is correct; all chemicals are toxic. But it is erroneous to equate toxic with hazardous. Toxicity is the capacity to produce harm. Hazardousness is the probability that harm will be produced. All chemicals are not hazardous.

How do we cope with scientific advances, with the good and the bad effects? First of all, everyone must understand science. Past generations lived in what was perhaps an unavoidable ignorance of science. Today there is no excuse; everyone should have a basic understanding of what science is and what it can do. Lack of understanding breeds fear, and fear creates an atmosphere in which every advance is viewed as dangerous. Many people feel that if a thing is dangerous, it shouldn't be

allowed to happen. They want a risk-free society. But we can never have a risk-free society; nor did we ever have that. Rather than trying to eliminate risks, we should concentrate on learning about risks and about the consequences of accepting or rejecting them.

Probably no other recent event has been given more media coverage than the incident at Three Mile Island. But with all the doomsday predictions, in the final analysis no one was killed, no one was injured, and there was never any chance of a meltdown or an explosion. It was all in the minds of the people who were afraid such things might happen.

A study by Dr. Richard Wilson, of Harvard University, will give some perspective to what the risks of atomic energy really are. He compiled a list of various situations that present an individual with exactly the same risk—an additional one-in-a-million chance of dying at any particular time. These include: smoking 1.4 cigarettes, drinking one-half liter of wine, living two days in New York or Boston, living two months in Denver on vacation from New York, one chest x-ray taken at a good hospital, eating forty tablespoons of peanut butter, drinking water from Miami's municipal supply for one year, drinking thirty twelve-ounce cans of diet cola, eating one hundred charcoal broiled steaks, living 150 years within twenty miles of a nuclear power plant, living within five miles of a nuclear reactor for fifty years. In other words, peanut butter can be more dangerous than a nuclear reactor. But peanut butter is familiar, and so we are not afraid of it. Atomic energy is unfamiliar to most of us, and most of us are terrified of it.

If you asked me whether or not there is a chance of a nuclear accident in this country, I would say yes. Most people would then conclude that there *will* be a nuclear accident. But there is another kind of question that should be asked. Science doesn't deal only in possibilities, it also deals in probabilities, so the next question should be, what are the probabilities of that happening? And I would say, practically zero.

Whether or not a scientific advance will benefit or harm mankind depends upon how the new knowledge is used. Everyone should be part of determining how science is used, which is why it is so important that everyone be educated *about*, if not *in*, science. Science is not just for the scientist. There are ethical and moral and legal problems arising from the advances being made and used today. In vitro fertilization, transplants, surrogate mothers, gene transplants that can

actually change the personalities of individuals, support systems—these kinds of things, not moon landings, affect people's lives.

I've never subscribed to the idea of art and science as two separate cultures. Both seek to explain and interpret the world— in different ways, yes, but with the same fundamental objective. Art adds to our sense of beauty, but so does science. Science does not just add to our comfort or wealth or power; it also adds to our dignity as human beings, and to our sense of what is true and therefore beautiful.

In Greek mythology, Epimetheus gave out gifts that would allow all the species on earth to preserve themselves. To the birds he gave the ability to fly; their predators he made earthbound. Small creatures were made prolific, big creatures were not so prolific. Some creatures were allowed to burrow underground; some were not. When it came time to bring man from the darkness into the light, Epimetheus didn't have any gifts left. It was then that Prometheus came to the rescue with his gifts of fire—man's first venture into technology—and various skills. But even in the myth it was recognized that skills were not enough and that they might even be dangerous. It was then that Zeus commissioned Hermes to give man two other gifts: reverence for others and a sense of justice.

Our skills have enabled us to change our environment. Soon we will be able to change ourselves. This is a frightening thing, because it can be used badly, or it can be used beneficially. Together, we must decide.

For all practical purposes, we have the skills to solve what we call the major problems of the world. We can control population growth, if we want to. We can feed the hungry, if we want to. We can produce more energy than can be used. We can clean up the environment. We can do all these things with the technologies that are available now—if we want to. The problems of our time are not caused by technology, and they will not be solved by technology. They are moral and political issues. Science can help us solve these problems, but what the world will be in the future will not be determined by new scientific advances. It will depend on how we use them. And to use them properly and to our benefit, we must understand them, and respect them, and each other.

BY ROBERT L. OLSON

IMAGES
OF
THE
FUTURE

I've always had a problem with the concept of future shock. It's not that I doubt that in our society change is now coming so fast that it poses serious psychological problems; what strikes me is how we so easily become almost oblivious to constant changes in our world. So I'm going to try to make you think about the enormity of these changes—which are certain to continue, and perhaps accelerate, in the future—tremendous changes in technology, in social values, in politics and the economy and the environment. I think it is only be appreciating the scale of today's changes that we can see the role that the arts might play in shaping the future.

TECHNOLOGICAL CHANGES
Weapons The most dangerous technological advance in our time is nuclear weapons. Winston Churchill began his military career with a sword-and-pistol-wielding cavalry charge in the Battle of Onderman. The end of his military career was the time of Hiroshima. Today, there are fifty to sixty thousand nuclear weapons in the world, and we properly worry about blowing out the ozone layer, about nuclear winter and whether the fabric of our civilization could survive a large-scale nuclear war.

How large a jump in destructive power is this, compared with

the major advances that have occurred in the past, such as the invention of tanks, machine guns, gun powder, or metal weapons?

In the movie *2001*, an early sequence begins with one of the apes getting the idea of taking a bone and using it as a club. After he teaches this to the other members of his clan, they go to a watering hole and, wielding their clubs, drive off another band of apes. Finally, this inventor ape, in the exhilaration of victory, tosses his bone—the first weapon/tool—into the air, and in slow motion it goes up, up, up, end over end, until at the top of its arc the scene changes, and in place of the bone is an object of approximately the same shape: a nuclear battle station orbiting the earth in the year 2001. I think the jump to nuclear weapons is probably the biggest jump in destructive power, with the most fateful consequences for life on earth, since the invention of the first weapon.

From Evolution To Biological Revolution In our time, we have seen the development of recombinant DNA techniques and the beginnings of genetic engineering. I think the only past development that can be compared to this is the original domestication and breeding of animals and the cultivation of plants. As we begin to unlock the secrets of genetic engineering, we are beginning a process of shifting more and more from evolution by natural selection to evolution by conscious human selection. Evolution by natural selection has been going on as long as life has existed on our planet. As we transcend that process, we are making one of *the* jumps of all time.

Energy Slowly but surely we're coming to the end of the era of fossil fuels. In the past energy was so cheap that we never had to think about using it efficiently; it turns out that if we pay attention to design, a revolution in efficiency is possible. At the same time, we're exploring new "eternal" energy technologies, such as solar power and fusion and fission breeders, which could provide energy for the entire future of the human race. How big is that compared with past energy transitions? There have been many: the jump to electrification, to oil and gas, to coal, to water wheels and windmills, to agriculture. The latter can be thought of as an energy invention because it was an enormous forward leap in the efficiency of gathering and storing solar energy in caloric form. I think the energy transition we're in the midst of right now can only be compared to the development of agriculture, and perhaps to the use of fossil fuels. And both of those had enormous consequences: Agriculture produced civilization, and fossil fuels made possible

the industrial revolution. The transition we're making to high energy efficiency and eternal sources of energy is likely to have equally profound social consequences.

Transportation The kind of mobility that the widespread use of the automobile gave us and the ability to go anywhere on the planet in a day or two with jet aircraft were major advances in transportation. But our first steps into space are probably the biggest jump humanity has ever made. Arthur C. Clarke argues that when from the far future people look back at these first steps, our generation will be seen as having begun an evolutionary transition comparable to life coming out of the ocean and gaining a foothold on the land.

Information I would argue that what is going on now in information is as big as the greatest information transitions of the past, including the invention of writing and printing. Within our lifetime we have the possibility of what we might call "universal information access," by which anyone, anywhere will be able to communicate by voice, by writing, by visual images to anyone else, anywhere on the planet. Technologically, if not economically, everyone will have the ability to access information resources equivalent to the world's greatest libraries, and artificial intelligence will allow us to find the needles that we're looking for in these vast haystacks of information.

Automation The impact of automation will be felt in both the office and the factory, yielding productive powers that are orders of magnitude beyond all the pre-World War II tools.

Each of these advances—all part of the technological revolution of our time—compares in magnitude to the greatest previous advances in its respective area. Whereas in the past transitions occurred over many thousands of years, today major transitions in many areas are happening simultaneously within one or two human life spans. In technological terms, that makes ours a unique era of change.

CHANGING VALUES

My list of changes in social values is drawn from those that are agreed upon by two leading Republican and Democratic pollsters: Lee Atwater, former Deputy Director of the 1984 Reagan-Bush Campaign, and Pat Caddell, pollster for Gary Hart and Jimmy Carter. Both agree that the value shifts I will discuss are taking place; however, the interpretations that I will present are my own.

Although these changes have occurred to some extent throughout society, they are most evident in the so-called "Baby Boom" generation, which spans a broader age group in cultural terms than in strict demographic terms. Culturally, the Baby Boom generation extends from people now in their early twenties to people well into their forties.

Gender Roles "A woman should act according to her husband's pleasure, rather than her own, because his pleasure should always come before yours. A woman should not answer back or contradict her husband, especially in public, for it is a command of God that women should be subject to men, and by good obedience, a woman gains her husband's love. . .A woman may subtly counsel her husband against follies but should never criticize or nag, for the heart of man findeth it hard to be corrected by the domination of a woman."

The above is from a manual of female behavior published in Paris in the thirteenth century. Today it sounds hilarious, which is a sure indicator of how much the role of women is changing in our society. I would argue that the changes in women's roles that have occurred in the last few decades, along with a constellation of other changes—in men's roles, in attitudes toward sexuality, in family size and structure, in child rearing, and in income production—represent the most complete overhaul of gender roles that has occurred since the beginning of the Christian era. And many of us are impatient for even further change.

Attitudes Toward Nature *The Year 2000*, by Herman Kahn, which came out in 1967, was one of the books that set off the futurist movement, and for some time it was considered the magnum opus of future studies. And yet the book said nothing about the environment or pollution. Kahn did note the break-up of an oil tanker, "The Tory Canyon," in the English Channel during the year in which he was finishing the book, but he dealt with this disaster under the discrete category of "boat accidents." Only two or there years later, our entire society had restructured its patterns of thinking—bringing together concerns that had previously seamed unrelated, such as the Los Angeles smog, the DDT in mothers' milk, and the soap suds in our rivers—into a new concept of ecology and environmental protection.

This new way of perceiving nature—as a global, interdependent ecosystem—has political implications, but even more profound are the deep psychic changes wrought in each of us.

We now see ourselves not as above nature or outside of nature, but as manifestations of our planet's biosphere, as part of a seamless web which we cannot disturb without feeling the impact. We've begun to accept responsibility for working out a long-term fit between human technological society and the earth's natural systems.

Personal Fulfillment The Baby Boom generation has turned inward. We are becoming more and more concerned with the state of our *being*—our health, our fitness, our relationships, our ability to do something meaningful with our lives. As part of this, Baby Boomers have demonstrated a strong social conscience, in the civil rights movement and, more recently, in our response to South African apartheid. There is a strong belief in human rights and an acceptance of diverse lifestyles. Unlike the old "melting pot" idea, the new cultural pluralism celebrates the differences among people and thrives on the hybrid vigor generated by a heterogeneous society.

Anti-Bigness Another current phenomenon recognized by both Republican and Democratic analysts is a widespread nervousness about "bigness" and a preference for the small, the decentralized. Big organizations and concentrated power centers tend to encourage depersonalization and alienation, it is felt, and this feeling is expressed not only in anti-big government and anti-big corporation attitudes but also in negative attitudes toward big labor organizations. The new sentiment is that while big is sometimes necessary, it isn't necessarily better; better is better.

The desire is for greater community, for comfortable relationships within smaller institutions, and for small, human-scale units within large organizations. Small-scale pioneers and entrepreneurs, not captains of industry, are the heroes of the Baby Boomers. A strong sense of the importance of empowering people, a preference for government that is more participatory, and a willingness to join and support various social movements are corollaries of anti-bigness attitudes.

Global Awareness As a television generation, Baby Boomers have seen more of the world than any generation before, and we are inclined to be sensitive to the problems that exist in the larger world. People tend nowadays to be less nationalistic—not less patriotic but more broadly identified with the human family. There is a certain respect for nonviolent change, a tendency to be anti-interventionist in foreign affairs, a strong desire to see improvements in U.S.-Soviet relations, and a belief

that we need to make nuclear weapons impotent and obsolete, which President Reagan fastened on in his "Star Wars" speech.

Commitment And The Desire To Do Great Things In adulthood, the Baby Boomers have taken longer than any other generation to make major commitments, whether to marriage or to particular lifestyles or careers. But it is beginning to happen. People are beginning to feel that something is missing in their lives, and there is an increasing awareness of the gap between values and lifestyles. Although the Baby Boom generation has a collective sense that they have done great things in the past and can do great things again, they are beginning to feel that the lives they are leading now are mundane and ineffectual. There is a growing desire to regain the kind of energy and idealism that was once integral to their lives, and to combine that with the know-how and realism that come from experience.

These changing values and attitudes are not uniform throughout society. In some people they are strong, in others not so strong. But overall they are the gestalt of the Baby Boom generation, and I would argue that, taken together, they are on a scale equal to that of the technological revolution.

Global Problematique This term, popularized by the Club of Rome, refers to a universe of interacting, interrelating global problems that cannot be isolated and solved individually because their roots are intertwined. These problems are real, but just as significant as their reality is our sometimes painfully suppressed awareness of them. We don't like to think about these things because in most cases we don't have the faintest idea what to do about them. But we know that they're there and that they're going to have to be dealt with.

The most obvious is the danger, and concomitant fear, of nuclear war. The possibility of major climatic changes induced by carbon dioxide in the atmosphere also makes us nervous, as does the hole in the ozone layer that is appearing over Antarctica. And the fear of global ecological degradation, deforestation, and species loss haunts us constantly. According to a conservative estimate, by the year 2000 about ten percent of all the species of plants and animals on earth will be extinct. That's the largest wave of extinctions since the disappearance of the dinosaurs sixty-five million years ago. But this time man is the culprit. We know we have to get our act together, but how? And what difference can an individual make?

The population explosion, along with massive urbanization,

is another global problem. By the twenty-first century, New York will no longer be one of the ten biggest cities of the world. It will be outranked by mega-slums in developing countries, where something similar to our Baby Boom is occurring, but on a far greater scale. The Third World's massive twenty-first-century youth culture will be a powder keg of frustration, and it is all to likely to lead to social and political instability, violence, and a level of terrorism that we cannot even imagine today.

POLITICAL IMPLICATIONS

Politics is going to have to be restructured in order to deal with the enormous challenges that confront us. How do we back away from the nuclear danger? How do we achieve harmony with nature? How do we safely and efficiently and economically accomplish the transition from fossil fuels to the new energy technologies? What are our priorities in space? How can we best harness our new information and communication resources and at the same time keep Big Brother from watching us? The benefits of automation will have costs in unemployment and displacement. Does society need a new system of income distribution, based on something besides work?

For the first time, the Baby Boom generation could be the dominant segment of our society in the 1988 presidential election, potentially comprising sixty percent of the electorate. As the most politically alienated generation in American history, it still lags behind its elders in terms of participation, but if the Baby Boomers become more activated, their new social values could dominate this country politically for many years to come.

We began to get an inkling of what might happen during the 1984 presidential campaign, when, after New Hampshire, there was a sudden surge of support for Gary Hart—largely from the Baby Boom generation—the likes of which nobody had ever seen. In three weeks, Hart picked up more support than Carter generated in a year, and his had previously been considered one of the fastest moves in American politics. When Mondale got the nomination, much of that support fell away from the Democratic party, and some of those people voted for Reagan.

The pattern of value changes can't be interpreted as simply liberal or conservative, as Democrat or Republican. These are deep cultural changes, and although both political parties are trying to identify with the ones that most closely parallel the planks of their respective platforms, neither party has been

completely successful so far.

ECONOMIC IMPLICATIONS

We are increasingly moving from an economy based on mass—on physical resources and energy—to an economy based on information. This doesn't mean that we're just pushing paper, that we've given up production. But it means that we're moving toward methods of production and patterns of consumption that use less energy and capital resources and rely more on knowledge.

Our economic sphere is no longer just local or national; it's global. The world is tied together by jet aircraft and communication satellites and world trade. Huge corporations are rapidly becoming planetary rather than national in their thinking. We're "planetizing" the economy, and much faster than people realize. We have some traumatic adjustments ahead. A growing focus on competitiveness in the global market place is necessary, but not enough. As Buckminster Fuller often said, we're going to have to learn how to "make the world work for everyone" in order to make it work for ourselves.

IMPLICATIONS FOR THE ARTS

While the problems encompassed in the concept of "global problematique" are enormous, it seems to me that, on the whole, the changes that are going on are in the right direction. Technologically we're moving toward higher efficiency, less waste, less pollution. The new ecological ethic, the focus on human development, the orientation toward global concerns, toward world peace—these are all positive trends. But the changes and the challenges are vast and complex and urgent and confusing. The arts can give us vision and help us cope.

In *The Image of the Future*, noted European historian and futurist Fred Polak traces how, in culture after culture, inspiring positive images of the future and mythologies about the past tend to arise before periods of cultural greatness. Images, Polak maintains, lead reality. He argues that in our society right now the great danger is that we've lost the vision; we've lost confidence in our vision.

Writing specifically about the arts, Polak says: "Today the artist has too often become both enslaved by and addicted to his own age. Art itself has adapted to the tempo of our modern times, ever straining to remain up-to-date. . .caught up in the present and not presenting an image of what could be that's

inspiring. . . .Art is both the measure and matrix of culture, is at once the crystallization of a developing culture and the chrysalis of a coming culture. Not only is degenerate art the fruit of the culture in decline, but it engenders further decay. The cycle can be broken, however. There are creative artists in all fields whose. . .image of the future can act as a regulative mechanism that opens the dampers on the mighty blast furnace of culture. The task before the arts is to find the best nourishment for a starving social imagination."

"May creative artists, and creative people in every field, find in their deepest selves the awareness and love and vision that can "open the dampers on the mightly blast furnace of culture." May new visions of where today's enormous changes could take us, if wisely guided, nourish our social imagination. May we make it through safely into that great realm of human possibility.

BY ROBERT H. LEONARD

A COMPATRIOTISM OF ARTIST AND AUDIENCE

I will talk today about ensemble, structure, and change. But first I want to talk about what the veterinary hospital smells like to my dog: the unbridled smell of fear, of panic in the face of death.

I'm not going to spend much time at it because I need to talk about ensemble, structure, and change. But the reason I want to talk about my dog's distaste for the vet's office is that I've recently been to the annual Southeastern Theater Conference Auditions.

This institution, its academic support system, and theater institutions in general throughout the country train the actor to be absolutely, entirely, and irrationally at the mercy of the potential or actual employer. That's why the audition process smells to the actor like the vet's office to a dog: It smells of panic in the absence of control.

We in the theater accept that as a fact of life, just as we accept that the actor, even upon graduation with advanced degrees, must have a "marketable skill"—like bartending.

I think there are some alternatives, and they all revolve around the function, purpose, and value of an ensemble approach to the practice of theater. The ensemble approach is not just acting in a few shows together. Ensemble is about gaining the skills to tackle the challenge of life as a stage actor—acting techniques,

yes, of course, but also an understanding of group dynamics, a grasp of the function of theater, the skills to create whatever environment is necessary for theater to happen—in short, real control over our lives as theater artists. This is the way out of the vet's office for our artists and our organizations.

Enough about the vet.

I believe theater is a community event. I also believe the theater artist (the actor, playwright, director, designer) can be described as a social artist who, like the social scientist, serves people by directly investigating, expressing, and interpreting who they are. Some theater artists are more conscious of this than others. Inevitably, though, every theater artist draws on and then plays to a specific community. Knowing your audience is a tribute to this concept. Knowing your community is even more to the point.

The extraordinary thing about the theater is that it is able to choose its community. The economics and technology of film and video force those forms towards metropolitan centers and require mass audiences. One consequence is the trend toward homogenization of cultural expression. Small ensembles— responsive, able, and effective—playing new works of their own creation in towns and cities all across the country can serve as a powerful counter-force to this tendency.

In this capacity, The Road Company, where I am artistic director, is striving to create a working environment for artists who want to apply their skills to the investigation and expression of our community in northeast Tennessee—who want to create plays imbued with the interests, concerns, and issues of this community as artists see them. As a consequence, we are also deeply involved in building an audience that regards theater as a window on life.

I believe theater audiences can engage in active contemplation, which is a rare event nowadays. I'm not talking about sitting-under-a-fig-tree-at-the-end-of-life contemplation but the periodic recognition of what's going on around us as we live. This miracle of seeing with new eyes happens when the audience joins the imagination of the production during performance. This concept assumes that theater is incomplete without an audience and that the enjoyment of theater is active, not passive.

I see The Road Company as a practical, ongoing experiment, investigating what professional theater artists can offer a normal American town. Originally conceived and run by artists who were willing to do nearly anything to work professionally in

Johnson City, the company has evolved from a loose, non-institutional collective into a successful ensemble of experienced artists struggling with insufficient funds and a thoroughly overwhelmed board of directors.

This season we are working on replacing the traditional model of the nonprofit board/staff partnership. We have come to understand that the artistic environment has to be created by artists, not by the board. The actors ensemble has assumed the responsibility for creating and maintaining the necessary environment for productive work as well as the responsibility for producing the work. Theater is a compatriotism between the artists and the audience, and we are developing that compatriotism into a league rather than a hierarchy. That league is centered on the energy and vision of the ensemble.

ISSUES, PROBLEMS, AND SOLUTIONS

As a veteran of both the CETA program (which helped launch us) and the NEA's Advancement Program (which helped us expand), The Road Company has taken root in a small community where neither theater-going nor nonprofit support is a habit. Between the efforts of our twelve-member board and the successes of recent seasons, a membership base of approximately two hundred individual and fifty business contributors has been firmly established, representing some $20,000 in annual contributions. That's a remarkable event. But these dozen wonderful people are not board of director types. They don't run in the circles of power in Johnson City or anywhere else. In effect, they have assumed full responsibility for the budget without the necessary time or resources. Worse, both the ensemble and the contributing membership have been seduced by the titles and the organizational charts of a traditional board/staff/patron hierarchy into thinking that not only will these dozen board members do it all, but they *must* do it all. The result: burn-out, frustration, and disorganization. The ensemble began to feel at the mercy of the successes or failures of the board's efforts, while the many interested members not on the board had little sense of how to lend a hand without committing to solving all of the life-and-death issues of survival and growth.

Our response has been to throw out the old model, expand our circle of willing volunteers, and design an innovative institutional system more appropriate to the people who make up The Road Company.

The ensemble recognized the need for the actors to take more organizational responsibility in order to get what they wanted— more working opportunities. We also wanted to reduce the burdens that had piled up on the few board and staff members and to develop a collective decision-making process. Instead of having the theater defined as just the actors, then, we understood that we *all* needed to become the theater: a group of complementary parts contributing to a single effect.

The result has been a complete restructuring of The Road Company. The Company is now managed by a partnership of ensemble and staff. The ensemble and administrative staff, called The Hub, is responsible for the existence of The Road Company artistically, financially, organizationally, and in all other respects.

Our new thinking also redefines public membership as a compatriotism between the actors and the public. Compatriot membership is annual and is established by voluntary contribution of financial support, personal time, or both. With the acceptance of greater responsibility by The Hub, we saw that the relationship among The Hub, the Compatriots, and the broader Johnson City community required a new link. The board of directors as originally conceived no longer fit this new role, and we decided that a Coordinating Team, elected as corporate officers from among the membership at the annual meeting, would better serve the organization. The Coordinating Team of these compatriot members assists in bringing The Hub together with the larger league of Compatriots and the general community.

Our sense of compatriotism, then, is based on the realization that our potential in Johnson City is dependent on a broad base of people who attend our performances and who actively contribute their time, energy, ideas, and/or financial assistance to see that the company flourishes. At the same time, we are shifting the responsibility for maintaining and developing the theater from the board to The Hub. Our model is no longer the traditional pyramid, but the wheel. The Hub is at the center of responsibility, and all ticket buyers, friends, contributors, and so forth are like spokes through their various activities. The Coordinating Team's function is to assist The Hub in bringing this sense of compatriotism to bear on the fundraising projects that each season presents.

This reorganization plan was presented and unanimously approved at the company's most recent annual meeting. The first step was to reduce the board from twelve to four people,

all officers of the corporation. The second was to hire the retiring board president as development associate. And the third was to agree that The Hub consisted of myself, the new development associate, and two senior ensemble members.

The results were immediate and startling. Members at the meeting who had never before volunteered offered their services, advice, and time. Previous volunteers, who had appeared worn out, rallied to take on specific time-limited projects. Although the reorganization was expected to reduce board meetings to quarterly events, the new Coordinating Team willingly offered to meet semi-monthly until the new system runs smoothly. (These meetings have been short and enthusiastic.) The year's projects are time-lined and given specific goals. Twenty-five new volunteers are involved, and we anticipate raising $20,000 to $25,000 through individual and business contributions and special projects—with each of these projects organized and coordinated by a committee headed by a member of the four-person Coordinating Team. The company as a whole anticipates that the successful accomplishment of this year's organizational and community development goals will be gratifying, not exhausting, experiences.

To my mind, the organizational alliance that The Road Company seeks is a mirror of the ensemble/audience alliance in a performance. We have become our own model rather than trying to fit someone else's. Our organization now reflects what is so special about theater, and in the process we have greatly increased our control over our company and its future.

This doesn't mean that we have accomplished a final fix. But it does mean that we are no longer dogs in the veterinary hospital of American Theater.

PART II

ORGANIZATIONAL STRUCTURE

BY DUDLEY COCKE

STRUCTURE: A WINDOW ON PURPOSE

Appalshop, from which Roadside Theater was to spring, began in 1969 as the Appalachian Film Workshop. The American Film Institute and the now-defunct Office of Economic Opportunity (OEO) had decided to start film and video training programs in a dozen communities with a high percentage of minority youth unemployment, and Appalachian Kentucky was selected as the only predominantly white and the only rural site. OEO's idea was to help the kids in the twelve programs join the American mainstream by giving them a head start in breaking into the television and film industries, which were, and remain, centered in a handful of our nation's major cities.

In eastern Kentucky today, the average per capita income for a family of four is half the national average, and the official unemployment rate is over twenty-five percent, with actual unemployment around forty-five percent. In 1969 the coal field economy was even worse. Between 1950 and 1969, four million (one out of five) Appalachians had left the region to find work.

In 1969, U.S. Steel, Bethlehem Steel, and the other large national corporations which had controlled the region's economy since the turn of the century were beginning to sell out. The coal fields were being bought by even larger and, to many of us, inconceivably complex multi-national corporations, such as Royal Dutch Shell and Occidental Petroleum.

In 1969, giant heavy equipment and weak or nonexistent land reclamation laws were making strip mining profitable, and in every coal county, the mountains were being torn apart.

In 1969, the Vietnam War was being fought with the lives of young people who did not have the opportunity to go to college.

And, how oddly fitting, in 1969 "hillbilly" was an epithet. It meant ignorant and second class.

It was at this time that the kids walked in off the streets of Whitesburg, Kentucky, to get trained for big-time television and film careers. However, because of the sum of these realities, they had little inclination to imagine themselves as future Walter Cronkites. Besides, they were seeing themselves portrayed regularly in the national media as the War on Poverty marched on, and what they saw usually offended them.

Perhaps in part because of this national attention, the OEO's TV and film equipment peaked their curiosity, and they started taking pictures of what was around them—the dirt car races, a hog butchering, summertime at the city swimming pool, footwashing at the Old Regular Baptist Church. It was not what the OEO and the American Film Institute had in mind.

Two short years later, the OEO had decided to scuttle the entire national program. But for the Appalachian Film Workshop, soon to become Appalshop, it didn't matter. The kids had made a discovery: they could make their own pictures, in their own image. And somehow these pictures and the stories they told seemed to have more substance and convey more truth than the stuff on national television, or in the California movies. How could this be? After all, these kids were nobodies, "hillbillies."

A little hope can be a contagious thing. Other kids in the region saw what was happening and thought, "If we can make our own films and videos, why not publish our own magazine, start a record company, begin a professional theatre?" Quickly, and at times painfully, the Appalshop came to learn that in dreams begin responsibilities.

Appalshop is a cooperative. Our organizational structure has evolved over the years to suit our growth and, more importantly, our understanding of our purpose, which from the beginning has been to act as a medium through which Appalachian people can speak for themselves. We are a worker-run, 501(c)(3) nonprofit corporation, with a board of approximately twenty directors who have worked in the organization for a year or

more. New board members are elected by a three-quarters majority vote.

The full board—the final arbiter on all organizational matters—meets quarterly to make policy, to formulate strategies and adopt plans, and to review all projects. A "junior board" of seven members drawn from the full board meets monthly to carry out board business between the quarterly full-board meetings. Standing committees—financial, program, fundraising, and personnel—meet regularly, sometimes weekly, to work on the board's behalf. There are also several community advisory boards.

Appalshop has five designated divisions: Appalshop films and video; June Appal recordings; WMMT Radio; Roadside Theater; and the Core. The Core is the administrative director, the money-raising director, the bookkeeper, and their assistants. It is also the catchall for projects which, for one reason or another, aren't organized divisionally. Each of the five divisions has a director, the idea being that the buck has to stop somewhere. Each division makes administrative and artistic decisions as a group, and within divisions there is a conscious effort to give some balance to each employee's job. For example, no one in Roadside can just do administrative work. No one can just do artistic work. Salaries—that ever thorny issue—are determined Appalshop-wide on a sliding scale depending on job responsibility and performance and years with the organization. If so inclined, one can work in several divisions in the course of a year. All Appalshop meetings are open to all staff, and there is a strong sense that Appalshop is a single organization with a unified purpose.

What theories have evolved alongside this work experience? One is that an organization's structure follows from the organization's purpose, and conversely, the way we organize ourselves is a window on our purpose.

With your forbearance, I'm now going to take a big step and look quickly at this relationship of structure and purpose within the context of our country's founding and Leo Tolstoy's speculations about art.

In his original draft of the Declaration of Independence, in a paragraph subsequently deleted by his fellow Congressmen, Thomas Jefferson argued for the abolition of slavery. He characterized its practice as "a cruel war against human nature itself, violating its most sacred rights of life and liberty in the persons of a distant people who never offended him, captivating and carrying them into slavery in another hemisphere, or to

incur miserable death in their transportation hither." What a tremendous disappointment that with all the revolutionary idealism of the birthing of our nation such a tragic compromise was made by the Declaration's editors.

It was this compromise, and subsequent, less tragic but no less profound compromises to the founding spirit of the country, that worried Jefferson as he grew old. As a legislator, ambassador, Vice-President, and President, he often yearned to retire to his Virginia farm, which overlooked his birthplace. By disposition, he was a homebody. But retirement did not bring its expected peace. Jefferson worried more and more about the wrong fork in the road that he feared the nation had taken. The right fork, to his mind, relied on the will and consent of the majority of ordinary people, not the ascendancy of a new ruling class. The right road was wide, paved with a broad-based economy of small businesses and farms. The wrong road was narrow, the result of a trickle-down economy controlled by large banking institutions and monied corporations. He advocated a decentralized government which encouraged debate and public involvement. He feared the Federalists' efforts to consolidate political power, believing that such a centralized government presumed that the people could not be trusted, that in fact they must be manipulated in order that their best interests, and those of the nation, be served.

In his book, *What Is Art?*, published in 1896 after nineteen years of writing and rewriting, Leo Tolstoy listed some of the effects of bad art. With a slight change here or there, he could have been listing the effects of bad government as Jefferson understood it.

Bad art, Tolstoy said, keeps the privileged from questioning their privilege. It encourages the people to hold beauty above morality and to put pleasure before truth. And it promotes the worst of feelings, like chauvinism and vanity. He contended that the philosophical science of aesthetics was created in the 1700s from the need of the privileged to justify their pleasure apart from considerations of the common good.

Tolstoy believed that good art, like Jefferson's idea of the American Revolution, should embody the highest perceptions and ideals of its age. In the twentieth century, he identified these ideals as humility, compassion, and love, and he believed that art should help draw humankind together. "The subject matter of the art of the future," he wrote, "will be either feelings drawing men toward union, or such as already unite them; and

the forms of art will be such as will be open to everyone."

Fifty-seven years ago Donald Davidson wrote in *I'll Take My Stand*:

> When material prosperity has finally become permanent, when we are all rich, when life has been reduced to some last pattern of efficiency, then we shall sit down and enjoy ourselves. Since nice civilized people are supposed to have art, we shall have art. We shall buy it, hire it, can it, or—most conveniently—manufacture it.

In such a relentlessly profit-driven country, where nonprofit organizations are an oddity, what should "nonprofit" mean to those of us who run these organizations? Is it mainly a philanthropic convenience? Or do we regard it as the bold alternative that the word suggests? Corporate structures fit their purposes: unremitting growth and maximum profit based chiefly on the capitalization of applied science. Such a purpose emphasizes efficiency over participation, mobility over attachment to place, manmade order over the natural world.

What I'm suggesting, of course, is that as cultural workers, we are in the thick of this ideological battle, this battle of two very different philosophies that have historically contended to shape American democracy and culture. This is a context that our work has inherited. We must not let the often terrible press of details in our businesses deflect or obscure this inquiry about our purposes or our structures, for the alternative to such investigations is to be carried along with a prevailing tide. This may be, by turns, good and bad for business, but it surely spells failure for a democracy and for a culture.

6

BY NELLO MCDANIEL

ON STRUCTURE: TOWARD A NEW SYNTHESIS

As the old saying goes, "If it ain't broke, don't fix it." But what if it ain't broke and *still* doesn't work? This is more than a mere riddle. It describes the living reality of many of our small dance and theatre organizations—be they individual artist-run, collective, ethnic and minority, or any other out-of-the-mainstream group.

In past years I spent a lot of time working with artists, trying to fit them into the traditional nonprofit organizational model. Prevailing wisdom says that at a certain time and place in an artist's growth, it is appropriate and necessary to take on the organizational trappings. It was about two years ago, while I was meeting with yet another outstanding choreographer about her "organizational failure," that I finally had to admit to myself that the traditional structure no longer makes sense for most individual artists.

This artist was like many others; the names change but the circumstances remain the same, and the story goes something like this:

"Last year was going to be the big year—going 50I(c)(3), hiring a manager, putting the dancers on 26-week contracts, having access to all the dance company funding that isn't available to an individual artist. So what happened? My three good friends who agreed to be my board had great intentions

but no idea how to serve as a board of trustees, and none had money or access to money. They're all in therapy now, trying to cope with the guilt of failing me. The young manager I hired— short on experience but long on enthusiasm—burned out four months into the job and is now selling real estate in upstate New York. And I ended up doing umpteen Affiliate Artists gigs just to pump enough money into the company to keep the dancers on contract. This new organization was supposed to serve as an important resource for me, but I am suddenly the principal resource for a small business. None of the creative and performance work I needed to do got done, and now I have no idea where to turn with a deficit and a lot less energy and confidence than I had a year ago. What am I doing wrong?"

The question is fairly typical of people in our business. The first instinct is to assume that I or we are doing something wrong. These days, my answer is: "You are doing nothing wrong. You're just not doing anything differently." For twenty years or more, we have been using the same old organizational approach, based on the same old assumptions that whatever works big will work small. If the traditional model works for American Ballet Theatre, the Guthrie Theatre, and the Cleveland Orchestra, we insist, then it will work for Dianne McIntyre, the Road Company, and MoMing. But if we are truly honest, we must admit that even when the funding climate was good, the traditional organizational approach worked only marginally well for small groups.

We have to start thinking of growth for small organizations very differently. The process of growth for a small arts organization is not linear; it is not simply a matter of adapting and absorbing incremental growth—planned and unplanned— over time. Instead, the small group goes through many different cycles, and each cycle is a unique process—the process of restructuring, reinventing, and otherwise adapting new structures to accommodate new ideas and new information. Furthermore, these new ideas and information may or may not be related to the ideas and information that were applicable in the immediate past.

Don't get me wrong. Some small arts organizations are operating successfully within the traditional structure. But many others are following tradition merely in order to function on the most basic level because that is better than not functioning at all. In too many cases these structures are little more than cardboard cut-outs which provide an adequate "visual sense"

of organization. Behind the cut-outs, the artists and managers are often engaged in guerilla programming in order to make the work happen.

The simple fact is that, with small arts groups, we are not dealing with nifty little clockwork organizations; nor are we dealing with always-known quantities. The notion that what can't be measured isn't worth knowing does not apply here. We are talking about structures that can only be measured in terms of how successfully the artist achieves what the artist seeks to do—not by how well the artist and manager keep the organization afloat and looking good.

The problem is that at no time during the last twenty years have we sought to develop a structure tailored to the needs and concerns of small arts organizations. It has been a constant process of adapting the large to the small, the known to the less known—of retrofitting rather than fitting.

How do we begin to develop structures that are more appropriate? The process I suggest involves both specific tasks and new ways of thinking that might put us on a more productive path.

First, we must rid ourselves of some of the old notions and concepts. Marilyn Ferguson observes, in her landmark book *The Aquarian Conspiracy*, that sometimes long after an old paradigm—a conceptual framework or model—has lost its value, it continues to command allegiance. The first step in breaking an old paradigm is to question the hidden assumptions, to call attention to inherent contradictions. There are many assumptions—some hidden, some not—behind the insistence that artists must form traditional organizational structures. Two of these are inherent in the traditional concepts of the board of trustees and the manager.

In the case of the board, the assumption is that a working, policy-making, fund-giving, fundraising board of trustees will provide the artist with the resources necessary to make art and deliver it to the public. The reality is that, for most artists, the initial board membership is a group of close personal friends whose primary, or only, assets are their belief in the artist and their desire to help out. At best, this type of embryonic board usually functions more like a small, volunteer work force than a working, fundraising board of trustees. Individual members rarely have significant sums of money to give to the organization or access to outside contributors.

In the case of the manager, the assumption is that a full-time paid manager will be able to organize and forcefully direct

the business of the company, thus freeing the artist to devote himself or herself exclusively to making art. The reality is that few small organizations have enough money to hire a qualified, experienced manager. And yet because there is no support staff, the person who is hired (usually for an embarrassingly low salary) is expected to be equally expert in every organizational function—from planning to budgeting to board relations to marketing to booking to fundraising. Many of these individuals might become truly outstanding managers if only there were enough time for them to grow into their jobs and learn the needed skills. But time costs money, and money is what the small companies lack.

Further contradictions between assumptions and realities can also be noted if we are alert to the instincts of the artists. Charles Moulton, an artist with whom I have been working for the last couple of years, pointed out that while the traditional dance company structure provides and maintains certain needed resources, it also *eliminates* certain resources—such as those artists and dancers who don't want to make a full-time commitment to a single company. Many artists need the constant, free flow of ideas and inspiration that a larger, less structured arts environment provides. Charles sensed that the traditional structure would isolate him, and for this reason he rejected the traditional model.

The second part of the process of developing new organizational models is to understand the real needs of the artist. This is easier said than done; the needs are complex and layered, and unless we take the proper amount of time and look deeply enough to find the problems beneath the problems, even what the artist tells us can be deceptive. When an artist is asked, "What do you need?" the response will often be, "I need to solve a problem." That problem—the immediate problem—is usually operational, and, not surprisingly, the solution will be organizational. So the cycle begins of organizational solutions addressing organizational problems while the artist's real needs, as an artist, remain largely unknown or unresolved.

When I speak of the artist's needs, I see them as being very specific and falling into two categories: creative needs and public needs.

In addressing creative needs, we must ask what the artist requires in order to make his or her work? What is the environment, what are the internal and external stimuli, the

necessary tools and resources? How does the creative process work and develop? What helps, what hinders?

The artist's public needs demand that we ask who the audience is for the work, and when is the best time to reach out to that audience? What does the artist need in order to deliver and connect the work to the audience? What does the marketplace look like, and how does it function best for the artist and the work?

The third part of the process is the development of a framework for synthesis. In general, most of us are trained educationally and culturally to be analysts. Our first impulse is to break a problem down and analyze its parts, and to keep breaking down and analyzing until we arrive at a set of irreducible components. Analytic logic tells us that once we've broken a problem down to its smallest parts, suddenly "it will all add up." Analytical skills are important, but we need to improve our synthesizing skills. We need to concentrate on putting the pieces together; we need to trust that if we really understand the artist's needs, those needs will begin to suggest structure and order.

For example, another dance artist I work with, Blondell Cummings, takes an idea and develops it over a two-year period. The work goes through an intense conceptual period, into solo and small ensemble work, into larger workshop and group work situations, even into video and film explorations. Ideas build on ideas: some are recycled and looped in various ways, some discarded altogether as part of the process. During the early and middle stages of work, it is sometimes hard to tell the difference between work participants and audience.

An appropriate structure for this artist is one that moves and evolves through time with the work. During the first six months of an idea, touring is not only inappropriate but distracting; in the last six months it is more desirable. For Blondell Cummings, any structure that is bound by a strict twelve-month cycle is going to interfere with the natural flow of the work. When a new idea is taken on, the old structure dies, and a new one must be born.

The fourth and perhaps most necessary part of this process is protection. Business scholar George Lodge, of Harvard University, asserts that any force of change will fail without protection from the inevitable retaliation of the status quo. This language sounds harsh and sinister, as though the status quo were actively and blatantly working to eliminate change. Most

often, however, the retaliation is very subtle and derives from genuine interest in and concern for the artists or their organization. But any time a small group tries a new structure and is forced back into a traditional mode because guidelines require certain quantitative procedures, this is retaliation. The status quo survives on sameness and conformity and known quantities. Sameness and conformity and quantification provide neither raw material nor inspiration for the making'of art. It is perhaps the greatest of all ironies that what was originally set up to protect the artist from the ravages of the real world may in fact be the thing from which the artist needs the most protection.

I sadly confess that protection is the one thing at this point in the process that I have no idea how to provide.

Running parallel with the process for developing new organizational forms that I have outlined is the need for greater acceptance and understanding of the following principles:

1) The success of individual artists and small groups must be measured in varied, ever-changing ways. Success will not be quantifiable in the strict, traditional ways; neither survival nor stability is an acceptable basis upon which to judge an operation.

2) No small organization will function long or well if the artist is not at the center of that organization and if all functions are not geared to the development and delivery of the artist's work.

3) The small artist-run organization must move in the direction of its most natural and logical marketplace. That marketplace may be a traditional venue, or it may be strictly electronic, or it may be some combination. Making work and connecting it with an audience is an organic process which we must be careful not to disrupt.

Our art forms rely on the vitality and productivity of artists working, quite appropriately, outside the institutional mainstream. There is a great deal at stake and much to lose if we don't find better ways for our small arts organizations to do business.

BY CHARLES V. RAYMOND

NYCB:
A
CASE
STUDY

The structure of arts organizations must continuously change to adapt to the pressures and interests of the outside world. In the arts, and especially in dance, the environment can be very insular. We must keep abreast of new and innovative approaches to management, and we must be willing to apply these tools to our organizations.

The arts are big business. Unlike most big businesses, however, the machinery that produces our product is made of flesh and bone, not steel. Our products are created by human beings talented in specific art forms. As arts administrators, we must be prepared to adapt the Harvard Business School approach to a business in which the products are abstract and the means of production are human; we must take this uniqueness into account.

Having been in arts management for only two years at the New York City Ballet, I do not have a broad perspective on the arts world, or even the dance world, in general. In discussing organizational structure, I will address specifically the operations of the New York City Ballet, beginning with a brief history.

Founded in 1948, the New York City Ballet joined the ranks of several other performing arts companies under the auspices of the City Center of Music and Drama. This umbrella organization was responsible for presenting the company, and

Ballet Society, the original organization under which the ballet operated, was freed from having to assume potential deficits. City Center bore the costs of stagehands, orchestra, musicians, and administration; the sole responsibility and focus of the New York City Ballet was making dances.

George Balanchine and Lincoln Kirstein, the co-founders of the company, were assisted by a small but devoted staff who were dedicated to dance and to the genius of Mr. Balanchine. Mr. Balanchine made all the decisions regarding artistic direction, dancers, touring, and performing. Mr. Kirstein worked behind the scenes to insure that the company continued to grow and that its future course was defined if not always secure. For the next fifteen years, under these arrangements, the company performed at City Center as well as in other cities in the United States and abroad.

In 1964, the company moved to the New York State Theater and became the first ballet company in the country to have a theater of its own in which to perform. On behalf of the Ballet and the New York City Opera, City Center leased the theater from Lincoln Center and to this day still operates the theater for these two resident organizations. During the preceding years, and into the following decade, City Center controlled the books of the Ballet, and revenue and expense were co-mingled with those of the Opera and other arts organizations under City Center's auspices.

In 1973, partially sparked by a large challenge grant from the Ford Foundation and the growing interest in autonomy for the Ballet, City Center restructured its accounting systems and segregated the Ballet's revenues and expenses. For the first time, the Ballet was aware of what its financial position actually was. It wasn't always a pretty picture.

Shortly thereafter, the Board of Governors of City Center, drawing from its members, created separate boards for the City Opera and the City Ballet. These boards had no policy-making authority and were strictly advisory in nature. During the following five years or so, new members were added to the Ballet board, and this body began to play an important role in fundraising for the company.

In 1976, the New York City Ballet hired a development director and began, for the first time, to contend in an organized fashion with its mounting deficits. The company was growing rapidly in both size and popularity, and the desire for independence was strong. In 1977, certificate of incorporation papers were

filed for the New York City Ballet, Inc., and the advisory board created by City Center became the board of directors of the new company. The board now controlled its own destiny, but in reality there was nothing to control. The final step, therefore, was the division of appropriate City Center assets between the New York City Opera and the New York City Ballet. This process took over five years; finally, in 1985, the transfer agreement was signed by both the Ballet and Opera.

During all these structural changes, the artistic side of the company never wavered. With the help of Mr. Kirstein, Mr. Balanchine had created a school which produced dancers well versed in the Balanchine technique and a company which provided the instruments for putting Mr. Balanchine's visions on the stage. The company attracted the best dancers in the world, drawn in large part because they wished to have the opportunity to work with Mr. Balanchine. The people who handled the day-to-day operations of the company were devoted to Mr. Balanchine, and most had been with him for many years. The organization was relatively "flat," meaning that, in one way or another, everyone reported to Mr. Balanchine, who had the final say in all matters. His decisions were carried out with the historical knowledge of his staff that his judgment was sound.

In 1982, Mr. Balanchine became ill, and during the next year he was less and less able to oversee the company's operations. Even though Mr. Balanchine was in his late seventies, no one had planned for this eventuality. The board now began to realize that it was going to have to play a significant role in the running of the company, and many members devoted a great deal of time and energy to ensuring continuity.

When Mr. Balanchine died, in 1983, he left behind one of the greatest dance companies in the world and the greatest body of work ever created by one man for the art of ballet. Obviously, company members were stricken with grief, and the board, seeing the need to establish a sense of stability, literally moved into the Ballet's offices.

In consultation with Mr. Kirstein, the board—headed by its chairman, Orville Schell—decided that the artistic leadership of the company should be divided between Peter Martins, who at the time was still a principal dancer with the company, and Jerome Robbins. They were given the titles of ballet masters in chief, and their responsibilities were divided so that they shared in all artistic decisions of the company. Mr. Robbins oversaw the staging of his ballets, and Mr. Martins took on the

responsibility of the Balanchine repertoire as well as his own and the day-to-day artistic administrative work. Many of the staff, having been with Mr. Balanchine for years, found it difficult to adjust to the new dual leadership, and some of them left. But others stayed on to help with what was to become an exciting new beginning.

The board and the two ballet masters in chief agreed that someone with management skills was needed to supplement the abilities of Peter Martins and Jerome Robbins. In January, 1985, I assumed the title of managing director of the New York City Ballet, replacing the outgoing administrator, who was leaving after over thirty years with Mr. Balanchine. The decision by the board and the artistic leadership of the company to use a recruiting firm and to hire someone who had no prior experience in running an arts organization, let alone a ballet company, was significant. It was an affirmation of the fact that the organization was changing and, in some ways, becoming more complex, more of an institution and less of a reflection of one man's vision. It was also a recognition on Mr. Martins' and Mr. Robbins' part that the company needed certain skills that they might not have. I complement them and give them the time to do what they do best: choreography, casting, and teaching.

The history of the New York City Ballet illustrates how, over time, an organization can adapt itself to changing needs. During the last forty years, our company has made a series of major changes; yet each of them has strengthened the company's ability to do what it was meant to do—produce dance.

Two observations which I made early in my relationship with the New York City Ballet are worth sharing at this point.

First, a person from the outside world, as I was, is looked upon as some kind of Martian. What is he doing here? Where did he come from? Look at the pinstripe suit. Do you think we can talk to him? How will he understand our specialized world? He doesn't know dance, so what contribution can he make? Questions like these came from both staff and dancers, and it took me a long time to gain the confidence of the "ballet people."

My second observation was that the staff that was already in place at the Ballet—about twenty-five in administration, including the development department—were devoted to their work, to the art of ballet, and to the company. This, of course, was a great advantage. But I realized that, even with such fierce

devotion among the staff, there was much to be done in improving and restructuring communications and relations among departments, both artistic and administrative, involving the financial reporting systems, and in working with the board leadership to strengthen that body by adding new members from the corporate community. I am also responsible for all union negotiations and for press and public relations. The administration of these along with numerous other tasks secures and enhances the foundation of artistic excellence that we have inherited.

During the next five years, the greatest challenge we face is to develop a new identity that does not stray from or contradict our heritage. (It is interesting to note that of the one hundred dancers in the New York City Ballet today, over half joined the company after Mr. Balanchine died; this also holds true for the administrative staff.) Actually, this challenge is itself part of our heritage, for when Mr. Balanchine ran the company, he was constantly taking risks and trying new things. We believe that it is our responsibility to maintain both the Balanchine repertory and the Balanchine tradition of risk-taking. All companies with a strong founder and spiritual leader must eventually face this prospect.

A second challenge which all of us in the arts must face is that posed by rising operating costs coupled with the continuing shrinkage of available funding. Government at all levels is cutting back its support, and these agencies are going to be forced to choose between supporting fewer companies adequately or funding a larger number inadequately. The effect of the new tax bill on corporate and individual patronage is self-evident, and to counteract this, along with the decline in government funding, we are currently trying to identify and involve individuals, organizations, and corporations in new and creative ways. We have also developed a much stronger emphasis on marketing, advertising, and program content.

A third problem is the spiral in production costs caused, in part, by rising union demands. We need to find new ways of rewarding people for their labor and years of service that will not cripple arts organizations financially. We need to help unions think creatively with us in these areas.

I can't predict what the world will be like for nonprofits in the next five or ten years, but I do know we are in a time of rapid change. The best way to prepare for change is to keep looking around corners, trying to take advantage of the changes,

sometimes by taking some calculated risks. Flexibility is the key—flexibility in our thoughts, in our ideas, and in how we relate to each other.

PART III

THE BOARD OF TRUSTEES

BY BERNARD GERSTEN

THREE BOARDS

I would like to talk about boards from the perspective of one who has served on, or at the discretion of, three in particular: the board of the New York Shakespeare Festival, where I was associate producer; the board of the Feld Ballet, of which I have been a member for the past ten years, currently serving as treasurer; and the board of the Lincoln Center Theater, of which I am also a member as the Theater's executive producer. Except for the fact that they are all part of New York City organizations, they seem to encompass the range of board possibilities.

The New York Shakespeare Festival board is noteworthy because it has been so constant over the past thirty years. First organized by founder Joseph Papp, it continues to serve at his discretion. A number of years ago, when Joe was asked what his relationship was to board members, he responded, "I hire 'em and I fire 'em." That has always stood in sharp contrast to boards that hire and fire in their own right—and as a present employee of such a board, I appreciate the difference.

When Joe Papp decided to create the Shakespeare Workshop in 1954, he was in the forefront of those using the 501(c)(3) provision in the Tax Code to establish nonprofit theatres. He selected a half dozen friends who were willing to sign the incorporation papers, and that was how that board began. Three

or four of those people serve on Joe's board to this day; and of the twenty-plus members of the board, probably fifteen have been there for over twenty years. That is remarkable constancy.

But I should point out that the relationship between Joseph Papp and his board was based upon a very significant understanding: If he ever got the organization into economic difficulty, it was his job—not the board's—to bail them out. And that has always been the case. Fortunately, the Shakespeare Festival now has one of the largest endowments of any performing arts institution—some $20 million—and that goes a long way toward solving any financial strain that the Festival may experience.

The New York Shakespeare Festival is clearly a very potent example of one kind of relationship between a board and the organization's top person. But relatively few performing arts institutions have remained under the same leadership for thirty-two years. Indeed, there aren't many that have even been around for that long. I attended a fundraiser for John Houseman recently. Hearing a review of the life of the Mercury Theatre and an allusion to the Federal Theatre, it struck me how transitory the institutions of the thirties were, compared with today. It's to our credit that many of us have managed to sustain ourselves over extended periods, in sharp contrast to those institutions that appeared, flourished for a moment, and then disappeared.

A board that forms around an individual artist like Eliot Feld is, to me, the most interesting kind of board. When an artist says, "I need a company, a theatre, rehearsal space," his or her needs become much more complex than those of an artist who only requires supplies.

The board of the Feld Ballet is a very different creation than the one that Joe Papp created. This is true in part because it's only been in existence for ten years, which is a short time in the life of a performing arts group. The Feld board still represents just a half dozen friends who believe in Eliot's work and who do as well as we can to solve the financial problems that having a dance company entails. But there are no solutions— none within our grasp as a young institution—that will last beyond three to six months. The board has had some success approaching individual donors, who have helped us from time to time. But such a board is not a universal problem-solver and never will be.

Now, very briefly, I want to discuss my experience with the

most extraordinary board that I've ever encountered. When I call the Lincoln Center Theater board "extraordinary," I know it sounds self-serving since they hired me. But that's not the measure of them. The measure of them is that they undertook— and succeeded at—a most unpromising task: the opening of what had seemed an accursed building, the Vivian Beaumont Theater.

I won't go into all the details, but if you followed the news, you know that the Beaumont has been dark a good deal of the time since it was built. You also know that the previous head of the theater and most of his board had insisted that major reconstruction was needed before the building could be used satisfactorily. Now only five of the twenty-six members of the Lincoln Center Theater board are around who served during that period.

This board is not the kind that forms around an individual artist or an artistic impulse, but its members are no less remarkable for their spirit and commitment. They didn't say to themselves, "We want to help fulfill a vision." They said, "There's an empty building at Lincoln Center, and that's not appropriate. We want to light it." They chipped in, formed a search committee, hired management, provided funding, and continue to give so much of their time that I'm embarrassed whenever I have to call them—which I do with great frequency. Furthermore, they understand that their responsibility does not include the artistic management of the Theater.

I'll stop now in order to take your questions. But as you can sense, the board that I feel most strongly about is the one for which I work. They have been so supportive that Gregory Mosher, my colleague, and I wonder virtually on a daily basis how long this honeymoon can go on. While we wonder, we'll continue to enjoy it.

9

BY LEON B. DENMARK

BACK
TO
BASIC
CONSTITUENCIES

When I first began working in the nonprofit arena, most boards consisted of the founder—an artist who usually served as president or chairman—and two or three friends who took on such titles as treasurer, secretary, and vice-president or vice-chairman. Obviously, these boards were constituted simply to satisfy one of the state government's requirements for forming corporations.

If the founder was lucky, from time to time one of his board member friends would be able to contribute a few dollars or turn him on to a source of contributed income or host a party for the company. But very rarely was such a board able to provide the company with significant financial support for its artistic endeavors. The artists and their organizations were able to survive under such conditions primarily because the government, through the New York State Council on the Arts and the National Endowment for the Arts—and, at that time, even the New York City Department of Cultural Affairs—was giving relatively large subsidies to arts organizations. Indeed, the government was actively looking for reasons to give money to artists and their organizations.

I was working for a dance company at the time, and that was when the Endowment's dance touring program began. Dance companies were able to pay their way almost effortlessly from

the income they earned by dancing their way across the country. But even then we were being warned of the necessity to diversify, to broaden the support base of our organizations. We were also being strongly advised that the only way to do this was to expand our boards of directors—to increase the numbers and broaden the "types" of people sitting on them. Large organizations—the Metropolitan Opera, the New York City Ballet, the New York Philharmonic, Lincoln Center, the big museums—were constantly held up as models.

We were not opposed in principal to this method of insuring and enhancing our future financial health, but most of us simply did not have the time to pursue it. Or we didn't have the appropriate personal associations or the money to pay others to develop them. We were constantly talking about board expansion, about the need for it, about what it could do for us, but we simply didn't have the wherewithal necessary.

Then the storm clouds really began to roll in. Cutbacks in government subsidy, which had been threatened throughout the seventies, became a reality in the eighties. At the National Endowment for the Arts, there was a major reduction in funding; grants from the New York State Council on the Arts, with the dollar amounts frozen, decreased in value in the context of rampant inflation; and for most of us, the New York City Department of Cultural Affairs virtually ceased to exist. (It is only now that that source of revenue is starting to come alive again.)

This very real shortage of money compelled those of us who were still around to do whatever we had to do in order to survive. For many of us, this included expanding our boards, quite often with the help of friends at the Endowment, the Ford Foundation, and other supporters. Everywhere you turned, you would find arts organizations recruiting vice-presidents of this corporation or that corporation, prominent political figures, and well known and lesser known social figures, and *attempting* to recruit wealthy patrons. We got lawyers to contribute legal advice, accountants to contribute fiscal advice; we solicited the contributed services of all kinds of professionals. Our efforts were inspired by the success of the regional theatre movement, which showed us that not only could these types of boards give us adequate operating funds, but they could also help us build endowments that we believed would ensure our financial security in perpetuity.

And here we are. I would venture to say that for the last five years most of us have had boards of directors made up

of new people, good people, people who have had, and continue to have, the best interests of our groups at heart. I am equally sure that most of us have concluded that there are only one or two wealthy patrons in town and that someone else has them; that the lawyer and the accountant on the board really don't have the time to give the arts organization the help it needs; and that as beneficial as it may be to have as board members the vice-president of public affairs of a large corporation or the president of One Hundred Black Women or even the vice-president of a bank, this does not eliminate the organization's financial difficulties.

For one thing, these people usually sit on several boards, and since most of them are working people just like the rest of us, they don't have enough personal resources to spread, even thinly, among all the groups with which they are associated. Secondly—and more to the point, I think—I've come to the conclusion that unless you can obtain the direct participation of a corporation's chairman, or at least of a senior officer (a president or senior vice-president), the ability of the corporate board member to deliver needed revenue is very limited. Often these funds have strings attached. What a corporation terms "special grants" may not be grants at all but, rather, contracts for which the arts organization has to work very hard to earn a slim margin of profit.

Let me emphasize that I am not unappreciative of the efforts of my board members or yours. I am simply saying that these people work for their corporations and that they must guard their own positions within those corporations. In trying to garner support for the arts, the bottom line is that they must deliver a product from which the corporation can benefit. Therefore, when we do receive corporate monies, we are not receiving grants; we are being used in some way to help market the corporation.

This is all fine and dandy. Over the past few years, this money has been very helpful. But our venture into corporate America has not proven to be the fiscal panacea that, back in the seventies, we were led to believe it would be; it has not solved our financial problems. And if it goes on too much longer, it will tear even more at the very worn fabric of our artistic efforts.

I am speaking primarily here about our country's small and medium-sized organizations, those in the $500,000-per-year to $2-million-per-year budget range. By contrast, I'm under the impression that for those major theatre companies that have become what we call the regional theatres, this system has

worked. I assume that it has worked for them because, in many cases, they are the only game in town, which means that there is little competition for local financial resources. That is certainly not the case for New York theatre companies of the size and type of the Negro Ensemble Company, and my observation has been that it is not the case for smaller companies outside New York City.

So the government won't support us anymore, foundation support has slackened, patrons don't exist, and, except for those arts organizations lucky enough to have the chairmen or owners of businesses on their boards, corporations are not filling the ever-widening gap. Where do we turn next?

I believe we must turn to our basic constituencies—even more than we have in the past—in order to develop the type of board that, freely and over a long period of time, can work aggressively to promote our interests. At the Negro Ensemble Company, for example, we hope to recruit people from the community who, as board members, will become politically active on our behalf. If our constituency—which in our case is primarily blacks—had been better organized and better represented on our board in the past, I don't think the National Endowment for the Arts would have found it so easy to reduce our grant. (I'm not saying that the grant would not have been reduced, only that it would not have been done so easily.) And most assuredly, well-organized, active, and effective constituent-based boards would not have allowed the New York City Department of Cultural Affairs to ignore the plight of the Negro Ensemble Company and similar organizations over the past ten years. For the future, once we have accomplished this goal, it is more likely that the State Arts Council's budget will begin to catch up with inflation.

I am talking about recruiting community members who are already organized and who would be very much interested in putting their concerns and expertise to use on our behalf. I am not speaking exclusively of politicians. For the black community as a whole, the Negro Ensemble Company is important not only because it provides theatre, but also because it is one of the black community's oldest ongoing institutions. I think that among our constituents there are many who would strive very heartily for the continuance and prosperity of the Negro Ensemble Company, simply to preserve the institution.

We will organize our constituents and get their representatives on our board in the same way, and for the same purpose, that

a politician conducts a political campaign and includes his supporters' representatives on his campaign staff and advisory committees. We will turn to church leaders, to local political organizers, to leaders of such groups as The Deltas and The Omegas, leaders of the Uptown Chamber of Commerce and the Bed-Stuy Chamber of Commerce, block association leaders, youth organizers, and fraternal organizations such as the Masons and the Elks.

We need to engage these people in dialogues, to discuss the criteria we use in selecting our repertoire. We need to let them know how and why we have chosen and developed the particular artistic course upon which we have embarked. And we need to discuss with *them*—not just with their political leaders— the importance of institutions, especially the economic importance of institutions, to *them*, to our constituents. We must make it clear that, given the shortage of institutions in which blacks can learn the processes that occur in such an environment, the significance of the Negro Ensemble Company goes beyond that of just a place where they can go to see plays.

We need a grassroots dialogue. We must be prepared to engage in one-to-one conversations, if necessary, to explain what live theatre, as opposed to television, can mean to our society. If we feel that our work in the theatre is uniquely important, then we must be willing to roll up our sleeves and go to the places where our constituents come together to work for their particular causes and interests, and to the places where they gather to socialize.

We must prepare ourselves—though not anxiously—for the responses and challenges of these people, which likely will be much more aggressive and much more sophisticated than we might expect. We must be careful to keep our minds open to what we can learn about our work and about how our work is perceived by the general public. In the short run, discussing our art outside our artistic circles may give us a sense of harassment and aggravation, but in the long run, we will gain a broader perspective and deeper insights through which to create future work.

I also anticipate that politicizing our organizations in this manner will shift more influence into the hands of managers and out of the hands of artists, since the managers will be more involved in day-to-day efforts to organize supporters. Also, the willingness of supporters to rally around our cause will be based more on the significance of the organization as a community

resource, rather than on the significance of the artists associated with the organization. (I must say, however, that the administrative hoop-jumping that we are currently involved in has already resulted in a noticeable increase in the influence of administrators over that of artists, and with time, this shift is likely to become permanent. Maintaining a workable balance is just one more thing we must continue to safeguard.)

While I am certain that this process will require a great deal of hard work, of a different sort than those of us in the arts are accustomed to, and that it will require us to make some difficult compromises, it is, I feel, the only way we can acquire the political clout with which we can: 1) protect ourselves from the vagaries of shifting government preferences; 2) put even more pressure on corporations and foundations to fulfill their social responsibilities; and 3) deepen, among the general public in this country, the feeling for and belief in the importance of live performance.

I'm not suggesting that we replace the board members whom we added in the seventies and early eighties but, rather, that we supplement their efforts by opening ourselves to the needs and concerns of our basic constituencies and by inviting their representatives into our board rooms.

10

BY GEORGE THORN

REDEFINING THE ROLE OF THE TRUSTEES

How does an arts organization develop a dynamic and supportive board of trustees whose focus is on leadership and fundraising? This is the most difficult and complex question facing arts organizations today, compared to which putting on plays or making dances is a piece of cake. But the lack of such boards has resulted in a national crisis, and if the arts are to survive it, we must re-examine our expectations and our methods of approaching potential board members.

The symptoms of this crisis include increasing deficits, insufficient contributed income, tension between the artistic leadership and the board over the artistic mission, disputes regarding ownership, a "them-vs.-us" attitude on the part of board and staff, the firing of founding artists, and a move toward an authority structure that requires the artist to report to an executive director.

I believe all of these difficulties result from a board model, evolved over the past twenty-five years, which raises expectations and makes demands that are all but impossible for board members to meet. These volunteer community leaders are being asked to take on all the corporate, legal, fundraising, fiscal, and policy responsibilities for a business they know little or nothing about, while at the same time respecting the condition that the center of the organization—the mission and the work

itself—remain off limits to them. Board members are asked to hold the organization in trust on behalf of the community; to give money and raise money; to create and support fundraising benefits; to give freely and constantly of their professional services and expertise; to serve on committees, chair committees, and attend meetings; to be expert and far-sighted financial managers; to have clout in the community and to exercise that clout on behalf of the arts organization; to be unqualified advocates who love, understand, and support the organization's art and artists; to help lead the organization to success; but never, under any circumstances, to involve themselves in artistic decisions.

How did this model evolve? It certainly does not exist in the law. The IRS insists that state nonprofit incorporation requirements and educational criteria be met. But with regard to board members, state law confines itself to setting a minimum number (usually three), articulating their fiduciary responsibilities, and broadly defining the language of trusteeship. The model certainly does not exist in the for-profit board, where directors are paid for their services, no fundraising or giving is required, there are a limited number of committees and meetings, and the business is run by a large, well-paid, well-trained staff.

There are three factors we must understand in order to put the existing model and its evolution in perspective so that we can begin the process of redefinition.

First, we must look at an arts organization's need for contributed income. If it is possible for arts professionals to generate all the financial resources they need to meet their organization's needs, there is no *requirement* that community representatives be included on the board of trustees. In such a case, the professional staff can serve—and often has served— as its own board. If an organization's financial needs exceed the ability of the arts professionals to meet them, then it becomes necessary to look to the community for board leadership. To put it bluntly, the primary purpose of the board of trustees is to raise money.

Second, we need to clarify the distinction between board member as leader and board member as volunteer worker. In most organizations, trustees are fulfilling leadership and management functions and providing volunteer support. The two roles are fundamentally different, but in most cases they are treated as the same, and this leads to a confusion of purpose.

Third, funding sources and community leaders tend not to

trust professional artists and administrators to manage the affairs of the nonprofit corporation effectively and responsibly. As a result, in the present model, community leaders are placed on the board as a means of protecting the funding investment, the organization, and the community—protecting them from artists, in a sense.

Not only is this model not organic to the needs of the arts organization, but it also serves neither the board members, nor the organization, nor the professional staff. Creating a new, organic model will require a total redefinition of the role, responsibilities, structure, and profile of the board of trustees of the professional nonprofit arts organization.

Where to begin?

The first step is to approach board recruitment with much more honesty and integrity than we have demonstrated in the past. The primary purpose of the board is to give and raise money. We must stop being shy about this. If you are on the board of the United Way or a hospital or any other community charity, there is no question about your role and responsibilities.

In the arts, only at the largest and most prestigious institutions is it made clear that if you want to be on the board, you must give and raise substantial sums of money. At emerging, developing, and mid-level institutions, we beat around the bush. Our thinking has been: "If we tell potential board members up-front that all we really need from them is fundraising, then they won't serve. Let's first get them to be trustees, then we'll try to get them to be fundraisers." In far too many cases, board members have been accepted even after clearly stating that they will not give money and are not interested in trying to raise it. I suspect that one reason arts professionals at smaller institutions have been unable to be direct and honest in this area is that they are basically insecure about the worth of their own work.

How would I redefine the role, responsibilities, and structure of the board?

My approach would be to simplify and limit what the organization asks of its trustees, giving the board four duties:
1) Influencing the community at all appropriate levels.
2) Giving and raising whatever contributed income is necessary to meet agreed-upon budget goals.
3) Developing a nominating and recruiting process that constantly regenerates the board.
4) Fulfilling the accountability function of the board's statutory fiduciary role.

Major changes in board structure would include the elimination of marketing, planning, personnel, volunteer, and facility committees. Should the staff need assistance in these areas, task forces or special advisory committees would be formed from outside the board membership.

The first priority of the board, as a committee of the whole, would be the never-ending task of educating the community about the purpose and goals of the organization and the value of the work. In order to "position" the organization favorably among the community's other institutions, there would be an aggressive plan for influencing corporations, professionals, foundations, media, community leadership, the political process, friends, and community groups. After all, the board's fundraising function can be fulfilled only in the context of effective influencing.

The board would be a fundraising committee of the whole, with subcommittees organized for specific targets—individuals, corporations, and appropriate foundations—and for specific goals—annual giving, major gifts, debt retirement, special projects, capital campaigns, and endowments. These subcommittees would be encouraged to recruit non-board members to participate in fundraising activities. Benefits and special events would be developed outside the board by special committees or task forces.

With the full participation of staff, a board committee would develop an ongoing process for identifying, cultivating, and recruiting new trustees, thereby constantly regenerating the board and its leadership. The aim would be not just to rotate membership but to improve the board year after year, to allow the character and quality of the board to evolve as the organization evolves. The absence of a process for recruiting and developing the next generation of board leadership is one of the greatest failures of the existing model. Too many boards have become stagnant and have been unable to adapt themselves to their organizations' changing needs.

There would be only one other board committee: the finance committee. In its relationship to the board as a whole and to the staff, this committee would function in very much the same way that it is *intended* to function in the present model.

Arts professionals and arts organizations need much more from a community that what I have outlined above. But all of these additional needs should be contributed by community volunteers, not by the board. If the staff needs marketing

assistance, for example, a task force of marketing professionals should be organized to give the appropriate advice. When this function is given to the board, as it is in the present model, there is often confusion regarding the respective domains of the marketing committee and the marketing director. Is the committee simply making its expertise and advice available as a resource, or is it "directing the director" as his or her employer? Only when this function exists outside the board—at the staff's request—is it truly advisory. If the staff is unable to recruit the experts it needs, the board—as part of its influencing function—could lay the groundwork for obtaining the appropriate help.

Under the present system, the last item on the board agenda, if it appears at all, is the art and artists. But with the new approach, every board member must have a clear understanding of the artistic vision, mission, purpose, direction, and goals of the organization. Far more time and energy than before must be spent on this part of the cultivation process. Since the board's primary function is to give and raise money, it is essential that the board understand and *support* the organization's work.

By redefining and limiting the board's responsibilities as I have recommended, for the first time trustees will have the opportunity to engage with the artists and their art. Through this process of engagement, everyone's energies can be liberated and galvanized and brought to bear on the achievement of the organization's goals. The dynamic will not be a competition among rivals for power and control; it will be a cooperative effort among partners for ongoing education and mutual understanding.

Some may fear that in this kind of board, the trustees will want a greater say about the art. But I believe that if arts professionals are clear and forthright about the vision and direction of their organization, the prospective trustee will not join the board unless he or she can give wholehearted support to what the organization is doing. If the duties of the board are carefully spelled out; if the role of the board is accurately and explicitly defined; if the cultivation process is an open and honest exchange of information; if it is made clear that the trustee's job, though immensely rewarding, is difficult, demanding, and complex, then the decision to take a seat on the board can be trusted as an expression of sincere and informed commitment to the organization's goals. If the potential recruit decides *not* to accept the challenges of board leadership, he

or she can be enlisted as a volunteer and help the organization meet some of its other needs.

This does not mean that every board must have only the "big guns" and "heavy hitters" from the community—though board members should be confident of their ability to reach and influence the appropriate levels of community leadership. What it *does* mean is that every organization must first determine its appropriate size and scope and then scale its potential audience, funding, community support, and board membership accordingly. In this way, an organization maps out the universe it is capable of serving and being served by. Within this universe, finding the right board members becomes a function of knowing what to look for and where to look. For emerging, developmental, and risk-taking organizations, there are emerging, developing, and risk-taking individuals within the community. Some will be found among audiences.

Will people accept trusteeship if they are informed up-front of the trustees responsibilities and limitations as redefined in the new model? Again, if they are unwilling to accept this new definition of board leadership, they shouldn't be on the board.

Will an organization be able to recruit enough trustees to raise the money it needs? It is not a matter of numbers but of individual effectiveness. It is easier and more efficient to work with three people to raise a given amount than to work with twenty people to raise the same amount. Many times board members have said, "If we double our size we can raise twice the money." But I have never seen an increase in board size translate into an increase in contributed income.

If an organization decides to implement this board model, where should it begin?

If yours is new or just beginning the transition from artists-as-board-members to a board with community leadership, then you are starting with a clean slate. Your major challenge will be to muster the courage to approach prospects honestly and directly regarding what you require of board leadership. You must have the patience to cultivate prospective trustees one by one, and you must keep the growth of the organization in balance with the gradual development of board resources.

If the organization already has a community board, the process of redefining and remodeling can be difficult. I suggest that the board leader and the organization's senior staff work together to choose from the existing board those members who have demonstrated their potential to meet the new criteria. Use

this group to develop a plan for redefining the board. The board leader should then meet with every board member individually to discuss the plan. Everyone should be given the opportunity to accept the new challenge of leadership. Those who are not prepared to accept should be offered another place in the organization's corps of volunteers. If the organization is stable, this process can extend over a period of time. If not, it will need to be accelerated in order to secure new leadership.

None of my recommendations are radical or revolutionary. All I am suggesting is a realignment of responsibilities within the organization's body of community volunteers. But this means that the board of trustees must understand the arts organization's need for contributed income and must assume primary responsibility for meeting this need. It also means that the organization itself must "stop making nice" about the realities of board leadership.

PART IV

FUNDING

11

BY CYNTHIA MAYEDA

A PLACE AT THE TABLE

Washington columnist Neal Peirce (of whom I'm quite a fan) recently addressed a national gathering in the Twin Cities of corporate grantmakers. He spoke largely about the changing nature of American cities: the expanding needs of those cities, how we're going to meet them, and who's going to create the agenda. He said that we need a process to forge a new plan for our cities, and he described how we might develop that plan and then carry it out. People from all sectors of our society would be asked to sit down together and determine what had to happen.

I found that very intriguing, and I tried to imagine who would be seated at the table. I wondered—though only for a second, I regret to say—whether people representing the arts community would be present. I think the answer is pretty simple: not likely. Yet I have this deep-seated desire for us to begin to be part of the solution, if you will, and to cease to be perceived as part of the problem. I'm tired of hearing, "We have food shelves to fill and shelters to fund, so why are we still giving money to the arts?" It's a great frustration to me to which I've never really been able to respond adequately. Until now.

If the arts are so vital to the fabric of society, if they develop our resourcefulness and encourage creative problem-solving, then doesn't it follow that we ought to be among the people

seated at that table, helping to develop the strategies that will move our cities forward? With this in mind, I decided to look at a couple of gatherings in the Minneapolis-Saint Paul area that are not entirely unlike what Neal Peirce was describing.

The Minneapolis Foundation, our local community foundation, annually conducts what it calls the Itasca Seminar. Nearly a hundred community leaders—CEOs, leaders of nonprofit organizations, leaders of ethnic communities and communities of color, etc.—come together to address a specific topic. Last year the topic was welfare reform, an issue that every responsible American knows is important to all of us, and certainly to our communities. Yet of the eighty-six attendees, only two people were from the arts community.

Then I looked at another example, a meeting that we fondly called "Minnesuing" after the site where it was held. About four years ago, Dayton Hudson's public affairs department noticed that an unusual number of first-time city council members were expected to take office as a result of the last election. We saw this as the perfect opportunity to bring council members, the mayor, and other community leaders together before they began to address the big issues that faced the city. Forty-eight people gathered for three days, Dayton Hudson picked up the tab, and a great deal was accomplished. But not one person in that room represented the arts community. I wondered why that was and how it could be different.

I dismissed right away the possibility that the larger community is too limited in its thinking, too unimaginative to consider us. Then it occurred to me that perhaps they dismiss us because *we're* too narrow—because they think artists can only think about the arts.

I was reminded of Bella Abzug, who was ever articulate in arguing for a redefinition of women's issues. She said, in effect, "You may think that women's issues are only about reproductive freedom and equal pay. But don't tell me for a second that the military draft, the trade deficit, and the budget have nothing to do with women. That's insane! They don't call those 'men's issues,' and it's time that women were included into the circle."

Thinking about what Bella said, I had to wonder whether or not we also needed to force the argument about the redefinition of the art and artists' issues. But eventually I realized that the real explanation is even more troublesome. It has to do with those of us who work in the arts and the nature of our organizations.

Think about this: How involved are you, really, in your community? How *truly* integrated are you into the life of that community? Are you a full participant? It's my observation that, with rare exception, the answer is "not very" or "not at all."

Why is this? At least one answer is that arts groups are often incredibly fearful that if they have too close a relationship with their community, then the community will try to define the artistic product. Let me be very clear about this: I am not advocating the abrogation of artistic control, not in any way, shape, or form. But I am saying that we need to *listen* to our audiences. And when I speak of audiences, I'm not just talking about the asses that have already hit the seats. I'm also talking about those people who have the *potential* to come sit in your theatre and celebrate.

At some point in our cultural history, we departmentalized and institutionalized the relationship between art and the community. We created "outreach" programs which, in the worst cases, allow us to isolate our relationship with the community from the rest of our activities. We point to those yellow busloads of kids and say, "See, that's our outreach program at work." Or we select productions for special audiences. Surely I'm not alone in finding this approach to the community synthetic and even paternalistic. The notion that our relationship to the community can be a discrete activity is hogwash. It's like saying that the existence of a House Ethics Committee means the rest of Congress doesn't have to be ethical!

Community relations and audience sensitivity are not functions, but a way of thinking and operating. I've seen some incredible living examples of this in the last couple of months. The one I'm going to cite is a smaller grassroots organization, but what I'm talking about is not entirely a function of size. The example is the Omaha Magic Theatre, a place that, for me, is magic in more ways than one.

What I saw there was incredible. You walk in, and there's playwright Megan Terry sitting at a table about the size of this water pitcher. People come through the door; she knows most of their names. She knows who wasn't there for the last show, whose husband has the flu, and so on. As I watched her, I was reminded of the day before when she said to me, "You know, I have these conversations with the audience."

In the window were scratched notes, clipped articles, and miscellaneous photocopied items with more scotch tape than 3M has sold in four years. I suddenly realized that that

overloaded window was the conversation she was talking about—and I mean, a real conversation. People walking by this storefront theatre stop to read what she has to say about the next production. In addition, Joanne Schmidman, the founder and director, invites people to sip tea after a show and talk to the cast members—to meet them and tell them what they thought. I couldn't believe it; nobody ran for the door! Not only that, but they told the truth. Can you stand it? The truth! It was the most amazing thing I've ever witnessed.

This is a community in the heartland of America where financial resources are decreasing. The Omaha Magic Theatre has to rely on a lot of in-kind contributions. In the particular show I saw—a collaboration between the theatre and a sculptor—the artist required a great many ace bandages. Megan and Joanne went to the local hospitals and asked them to save all their clean, spare bandages. I was seated by two women from a local hospital who came to see those bandages, and I'm telling you, my dream is that they became subscribers and lived happily every after. I don't know whether that happened, but I do know that their first trip to that theatre was not intimidating—it had something to do with them and they felt some ownership of it.

Well, all this is great. But context is important, and I don't need to tell you how tough it is out there. The reality is, friends, it's going to get a lot tougher. In corporate giving alone, new pressures stem from mergers and acquisitions, takeovers, flat profits, changes in leadership, and tax law changes. At the same time, more organizations need financial support and less money is coming from the feds. That means you have more competitors out there—even municipalities and public schools are raising money now, not just hospitals and museums.

With increasingly limited resources, all of you need to think about whether you are strangers to your communities and whether they are strangers to you. If somebody else has established a real relationship with them and given them an opportunity to feel ownership, then when push comes to shove, there's very little question who's going to get their help. That holds true for audiences as well, who have increasing demands on their leisure time and disposable income. Where are they going to go? To the place where they feel connected.

Please, do yourselves the favor and the pleasure of thinking about how your relationships to your communities might be different. Dismantle your thinking about "outreach," if that's

a word in your vocabulary. Find a new way to think about your communities—a way that touches every corner of your business. I'm convinced the result will be richer work on your part, a richer experience for your audiences, and a place for you at that table.

BY SAMUEL A. MILLER

CHANGE IN THE FUNDING ARENA

Two current trends in the cultural economy disturb me, and to counter them, I want to take this opportunity to discuss possible changes in the way we go about the *business* of art.

These trends are 1) the diminished role of the artist in the funding process, and 2) the growing emphasis on "quid pro quo" funding relationships. Both are functions of gradual changes, primarily during the last ten years, in the way arts organizations are governed: the growing influence and importance of boards of directors in institutional management, the emergence of the managing director as chief executive officer (CEO), and the increased stature of the development department. These changes in governance have led to an increased emphasis on long-range planning—which often runs counter to the artist's intuitive creative process—and an increased reliance on market research, the results of which are being used not only to inform strategy but also, inappropriately, to alter product.

Market-driven planning has resulted in producing and funding organizations that are making program decisions in response to the perceived needs of customers rather than the real needs of artists. This is a shift away from art and toward the marketplace, and its roots can be traced to well-intentioned funding programs and to the dominance of the constituent model in the design of institutional structures for arts organizations.

To counter this shift, arts organizations must assert themselves as product-driven rather than market-driven. If the artist's role in the organization is to be properly recognized, we must abandon the constituent model of governance now dominant in the nonprofit sector and adapt the for-profit sector's proprietary model to our purposes.

In the for-profit proprietary corporation, the chief executive is empowered and obligated to maximize the economic value of his firm by any legal means. In the nonprofit proprietary model, we would substitute "creative" for "economic," so that the responsibility of the arts organization's officers would be to maximize the creative value of the firm.

The responsibility of a company's management is to develop the resources necessary to meeting this goal. In the proprietary model, management is led by the CEO, a paid executive who is usually also the company's board chairman and who is assisted by other paid executives, including the president, the chief operating officer (COO), and the chief financial officer (CFO), most of whom sit on the company's board. The CEO is usually the executive considered to be most knowledgeable in the firm's field of endeavor. It is appropriate, therefore, that in an arts organization the chief executive would be the company's chief artistic officer, its artistic director, assisted by managers with complementary expertise.

In order to fulfill the role of CEO, this chief artistic officer, or CAO, must be responsible not only for the development of the company's product but also for generating the financial resources required for production. This means that the CAO must serve as the arts organization's principal fundraiser and must control the company's revenue and program resources.

It is easy to get carried away with corporate lingo, which is often inappropriate in scale and vocabulary. Arts organizations should not be viewed as sophisticated corporate entities; they are, for the most part, small businesses. But this necessary adjustment in scale confirms the need for the proprietary model. Successful small companies are run by strong principals, by entrepreneurs, by chief executives who make and sell the product, who care equally about the firm's employees and its customers. If an arts organization is to be vigorous, the artistic director must have this kind of responsibility—and this level of authority—for making, managing, and selling the product. Cede responsibility for even one of these functions and the artist is liable to lose control of the organization.

Certainly the CAO needs assistance—a financial manager, a marketing director, even a member of the community to help attract capital. But there is no need for an outside chairman; the fact that individuals or institutions in the community loan you money or invest in your product does not mean that they should run your company. Primary leadership must reside in the artists' hands.

For this proprietary model to work, we must review, and perhaps modify, our sense of what motivates the arts contributor. In my view, all arts supporters and arts consumers (contributors and ticket buyers) can be divided into two groups: individuals and institutions. This division not only reflects my assessment of the different motivations driving individuals and institutions; it also provides the rationale for the elimination of the development department and the need for a constituent board, restricts "quid pro quo" fundraising to individual contributors, and affirms the role of the artistic director as the company's principal officer.

Individuals, whether buying a ticket or making a contribution, are purchasing goods and services: a single-ticket buyer wants a seat, a subscriber a better seat, a contributor access to the artist and/or social recognition. But the traditional development and marketing departments do not reflect this. When I started working at Jacob's Pillow, the situation I found was similar to that of most arts organizations I have encountered. There was a development department and there was a marketing department, two separate empires competing for resources and serving an overlapping constituency. There is now only a marketing department, which is responsible for all revenues— both earned and contributed—from individuals. Institutional support (government, foundation, and corporate) is the responsibility of our executive director—who is also our CAO— working with the managing director.

In analyzing program needs as prologue to soliciting institutional support, an organization should first maximize the revenue each program receives from individuals and then look at the bottom line. Those programs that then show a deficit should be examined to see whether they merit institutional support. If they don't, they should be eliminated.

Following that analysis, institutional support should not be solicited on a "quid pro quo" basis, but rather on the basis of established, appropriate, and articulated needs for subsidy that can be demonstrated on behalf of specific programs. Certain

programs should be priced below market value in order to provide broad public access; others require subsidy because, although they are important artistically, they are difficult and expensive to produce. These kinds of programs cannot, or should not, be asked to survive on the open market. In this light, the purpose of institutional support is to correct the inefficiencies of the marketplace.

The programs that require subsidy—especially those that Professor MacMillan at Wharton would call "the soul of the organization"—should be critical to the company's chief artistic officer. Their planning, production, and capitalization are the CAO's priority.

The development of individual support is a marketing function, requiring that—in a manner consistent with the organization's overall goals—programs and services be sold to consumers through traditional marketing strategies. Institutional support should be solicited as creative capital from government agencies, foundations, and corporations—the venture capitalists in the arts economy. But these institutions should not be investing with the expectation of a direct return. Their "investments" are gifts, and the programs they subsidize provide benefits primarily to others—to artists, to audiences, to students. This kind of transaction is unique to the nonprofit sector. It is what we strive for in health care, in education, and in the arts—gifts that accrue benefits to others, not to the givers themselves.

One of the things that distinguishes the arts from other sectors of the nonprofit economy is the difference, in terms of motivation, between individual and institutional givers. In my arts experience, individuals require direct benefits; institutional givers do not, or *should* not. That some do is partially the fault of the askers, and in the constituent model—where the askers are the givers—this problem can be traced to the issues of governance that I have articulated earlier.

I encourage the leadership of every arts organization to examine carefully these issues of governance and motivation. We do not automatically need managers as CEOs, or outside chairmen, or development departments. Management and board trappings should be minimal; they should play a more modest support role in serving the chief artistic officer, who must accept direct responsibility for program design and the solicitation of institutional subsidy while overseeing a marketing department's campaign for revenues from individuals.

CHANGE IN THE FUNDING ARENA

Sooner rather than later, our arts organizations should turn from the constituent model to the proprietary model. In so doing, it will be possible for artists to reassert their appropriate place at the top of the organizational hierarchy.

BY A.B. SPELLMAN

13

THE
NEW
PLURALISM

Before I begin, I want to emphasize that my remarks should not be taken as official policy of the National Endowment for the Arts. My reflections are simply from the perspective of a person involved in public philanthropy who looks out his window and sees the White House to the left, the Congress to the right, and a city down the street where developers are driving up real estate values and artists, among others, are scuffling to maintain their presence.

My first thoughts are a set of points having to do with what some call "new pluralism." The term implies that new communities of taste, of interest, even of sexual preference are being forged. New pluralism also implies a greater tolerance as people become more familiar with alternative lifestyles and alternative groupings.

Evidence of this increased tolerance can be found in the experience of the Expansion Arts Program, which I have directed for almost ten years. We annually go before the National Council of the Arts and explain why such a program is needed and why the field that is supported by the program is important to the Endowment and to the arts. Oddly enough, I think our program is more secure now—with a National Council that includes more members of the "New Right" than in the past—than it was under more liberal administrations. That indicates

that this increased tolerance has taken forms that are not always obvious and that can't always be anticipated.

Another characteristic of new pluralism is a greater distrust of institutions, beginning with the federal government and including big business. The distrust and suspicion of large institutions such as these filters down through our society in ways, again, that are not always obvious. But the public is demanding more responsibility, more control of institutions, more access to the kinds of information that institutions accumulate. Alternative institutions are being forged in the form of smaller businesses, greater entrepreneurship, and more local control. This is happening in all areas of commerce, including the arts.

Finally, also implied in new pluralism is that everybody's got an audience—if you can just identify it, attract it, and hold on to it. This point came home to me recently when the Expansion Arts Program and the Dance Program solicited applications jointly from dance companies that met the criteria of both. That meant they had to be deeply rooted in, and reflective of, a cultural minority—inner-city, rural, or tribal— and they had to have at least a twenty-week season of rehearsals and performances.

We got over two hundred inquiries from every kind of company imaginable. All of them were quite particular in their definition of themselves and of their art, and all have audiences somewhere, otherwise presumably they wouldn't be in existence.

There it is, new pluralism at work. But will our society be able to respond systemically to this trend—which I believe to be so healthy?

Arts organizations of all kinds have experienced enormous growth in the last twenty years. We've also seen some attrition in the nonprofit sector, which has not been altogether a bad thing. Obviously, when you have an explosion of this kind, not everybody is going to make it beyond mere survival to institutional longevity.

I believe this proliferation of nonprofits is attributable, in part, to the consciousness-raising of the sixties. At that time artists began to determine that they would no longer trust their careers and their lives entirely to the hope of recognition by the major cultural institutions. Instead, they began to found alternative structures which could complement their creativity— structures that fit their particular aesthetics and audiences.

But there's a trap in the tax code for such pioneers, and

that trap is called 50I(c)(3). It's more than just a law; it's the institutional model that it has created. As a consequence, artists often find themselves running small businesses—and pretty bad small businesses at that. Most of them will never make it on their own.

We have a contradiction here, and the contradiction is in the system itself. 50I(c)(3) was the creature of a generation of robber barons who, having anticipated the income tax, wanted an alternative. Their model was the trust—you've seen those old newspaper cartoons about trusts—and they designed their foundations, their hospitals, their schools and museums and symphony orchestras and opera companies all in the image of the trust. The governing principle was that they could secure the permanence of these institutions through tax-exempt endowments managed by wealthy trustees. They built concrete and marble buildings that wouldn't fall over when the wind blew hard. And last, they hired staff.

One of the points I want to make is that trustees, as founders and donors, see themselves as primary in the well-being of an organization. What's more, their tendency is to expect the organization to conform to their desire for administration. So a board gets together, and they bring in all the rich people they need to start an opera company and build a massive performing arts facility. Then they hire an administrator, who eventually goes out and hires the artists.

What's wrong with this picture? The problem is that a choreographer who just wants to "do dance" will likely have to adhere to this *same* sequence as she builds a company around her choreography. But these two organizations should not be expected to look alike or to work alike, and it's a flaw in the system that we treat—and judge—them the same. All small or mid-sized arts organizations should not be expected to operate like little Metropolitan Opera Companies.

I'm not saying that people don't need to think institutionally. But I am saying that not everybody should be expected to develop in the same way, or toward the same end, or following the same model. People should be able to think of their work as the development of projects that may last for a period and then go away. Not everyone feels compelled to build marble and concrete structures that stand forever.

New organizational models are needed, especially in a period when it is far harder to find the resources needed to establish an organization. This might well require some changes in the

tax code. Perhaps short-term renewable tax-exemptions—for, say, a five-year period—might be created especially for artists to do projects without trying to build institutions. Then funders could be encouraged to look at the artistic value of the projects instead of at their investment value as monumental enterprises. After all, isn't it worth remembering that the artistic value is far more important than longevity?

PART V

AUDIENCES

BY TISA CHANG

AUDIENCES, THEATRE, AND CHANGE

Pan Asian Rep is the ten-year-old theatre company of Asian and Asian-American artists in New York City. Our mainstage shows are performed in a 102-seat theatre space. We average twenty-six performances per production, four productions each season. When we began, on a Showcase Contract, we averaged twelve to sixteen performances per production. Now if we sold every seat at every performance for all four shows, we would reach over ten thousand people each season. This does *not* include our touring program, for which the average attendance is five hundred or more per performance, in public schools, in nearby colleges, and in Asian-American communities.

If I could, of course, I would wish for one hundred percent attendance at all our shows, with an SRO sign and a waiting list. As things stand, I hope that forty percent of our total audience attends all four shows. They represent an audience base that we can count on from season to season—ideally people who are so entranced by our artistic passion and so converted to our artistic mission that, in their eyes, we can almost do no wrong; audiences so captivated by the founding purpose of the company, so mesmerized by the resident actors, designers, directors, and the repertoire that they come back regardless of reviews, word of mouth, or even the occasional "turkey," of which we have had our share. (After all, Pan Asian Rep

was founded to promote professional opportunities for Asian-American theatre artists—including new Asian-American playwrights—not to promote a popular or safe repertoire.)

In short, our ideal audience believes in the importance of our very existence, either out of ethnic pride, moral conviction, or the worldliness of their artistic appreciation.

Currently another one-third of our audience comes to only two or three shows a year. Their selection process is more purposeful—they will skip the turkey. They may select a play on the basis of the playwright, the cast, the time of year, or simply because their schedule allows them to attend while a particular play is running. Ideally, however, these audiences are also so devoted to our company that they donate generously and regularly, buy tickets to our annual benefit, subscribe, bring their friends, and let us know their likes and dislikes. They seek and sustain a relationship with the company. They follow the careers of our artists. They *care* about the company. They may even be board material.

Those in our audience who see only one show during a season—perhaps thirty percent of the total—represent new blood. They may attend after reading a good review in *The New York Times,* or because their friends are talking about the show, or because it has been playing for some time in a midtown location. Last year our Indian play with music, *Ghashiram Kotwal,* attracted first-time attenders from the Indian community and people from the general population who were interested in the Festival of India. *Yellow Fever,* which ran for six months in 1983, attracted audiences from the commercial theatre world and from mainstream nonprofit theatre companies. Although these people may not attend regularly, they represent a new target audience. Ideally, they should all be on our mailing lists; even if they never become regular attenders, they may donate generously. Even those who never attend again will at least recognize our name: "Pan Asian Rep—they do good work." "Oh yeah, that comedy about the Japanese detective." "Pan Asian Rep—yes, they have a theatre near Broadway." The recognition factor is important, and so is the new blood.

I want our productions to touch people, to change people, to broaden their perspectives and their expectations, to open their minds and dispel stereotypical thinking, to stimulate, illuminate, and inspire audiences to reach new heights of artistic knowledge. I would like to know that they have learned at least

one new thing about the world or about themselves by experiencing our work. Theatre illuminates universal truths, but it also reflects each person's soul. It is a collaboration not only among the artists who create the final vision on the stage but also between the artists and the audience. We all know about the experiments in environmental or communal theatre in the sixties and early seventies—especially in the work of Grotowski, Peter Brook, and the Living Theatre—that depended heavily on the participation of the spectators, sometimes to their discomfort or outrage. But there is still, between the performers and the audience, an exchange of energy, of knowledge, of motivation. Many actors say that they perform differently at each performance, depending on how receptive or resistant the audience is. From one night to the next, there is considerable variation in what it takes, and when, to score a dramatic point or a laugh line.

Our audiences are tremendously diverse. Among the approximately fifty-five percent Asian and Asian-American are first, second, and third generational differences, as well as the differences between the Chinese, Japanese, Filipino, East Indian, and Korean segments of the population, not to mention the newer immigrants such as Laotians, Thais, Cambodians, and Vietnamese. Varying degrees of readiness for integration and assimilation into the American mainstream make our audience development efforts extremely difficult; it's as if we were targeting three or four completely different sets of population profiles. But diverse audiences are important to Pan Asian Rep because the diversity of reaction and appetite challenges our artistic drives. We are constantly learning new things from our relationships. We do not cater to audiences' whims, and I am careful not even to attempt to be *all* things to *all* people, though we do try to be responsive.

At Pan Asian Rep we have always valued human potential far more highly than high-tech glitz. But the general trend in theatre is the reverse of this. As we edge toward 2001, I fear the depersonalization of the performing arts. Theatre began as a celebration of cyclical events in nature—planting, harvesting—and as religious festivals. It is now fast becoming a sterile platform of high technology with an occasional solo performer or—going one step further—mannequins. I fear that designers will rely more and more on electronic devices—lasers, breakaway sets that appear and disappear at the push of a button—as substitutes for skill and creativity. I fear that playwriting is going

to be reduced to a series of vignettes or flashbacks or flashforwards, that it is going to become episodic or sitcom-ish. I fear directors whose ideas of contemporary relevance consist of chrome catwalks, mylar floors, and a Talking Heads soundtrack. I am afraid when I see actors use the living theatre as a conduit to Hollywood and TV Land. I am afraid that audiences will come to equate theatre with rock video.

Another trend that troubles me is the "institutionalization" of arts groups. The *business* of being an arts organization is taking precedence over the artistic imperatives. I shudder when I hear new or small groups talk *only* about subscription, benefits, board recruitment, what audiences will like or not like, and not about the art. Now that the nonprofit sector has been in business for twenty-odd years, there is a set formula for applying for government aid and set strategies for corporate and foundation fundraising. This year I have been invited to more cocktail parties and awards functions and been asked to serve on more committees and boards than ever before; I am in danger of spending more time on these activities than in the rehearsal room or the think tank. Yet isolated "think time," research time, and time for viewing other artists' work is essential to creativity. The creative process is the making of art; the perpetuation of art is a business. Institutionalization asks groups to conform, to develop in a uniform way. But some groups came into existence as alternatives to mainstream groups and are, by definition, artistic anomalies. While there *are* certain basic business practices of fiscal accountability and grant compliance, asking every group to develop according to the same bureaucratic formula is unrealistic. The dangers are a stultifying sameness in content and a superficiality in management style.

My third concern is in the form of a question which may have no answer: Will the theatre artist become an endangered species? The theatre will always pay less than TV or film, but is it still possible to make a viable wage in the theatre? And what constitutes a viable wage—$300 a week, $400, $500, $1,000? Is the artist who does not make a viable wage considered less of an artist? Can we justify paying annual wages to the artistic and managerial heads of organizations while the artists who make up the artistic identity of a company are paid irregularly?

Of the seventy-eight theatres listed with ART/NY, the New York service organization for local theatres, only six or seven are working on contracts paying $300 per week or more. Many are LOA (Letter of Agreement) companies paying $130 to $180

per week. This is a legal but unrealistic wage. And the vast majority of ART/NY companies pay even less, some of them next to nothing, because they are working on Showcase Codes.

Can we justify year-round organizations set up with paid personnel to promote art and artists when those organizations ask the artist to accept token payment? How does this affect the quality of the art? What effect does it have on the efficiency of operations? When the artists are paid so minimally, their union protects their right to accept a higher-paying job, and they sometimes simply take off in the middle of rehearsals because they've received a better offer.

How does not being able to make a viable living affect artistic commitment, idealism, focus, and discipline? Will the necessity of an additional "bread-and-butter job" be the norm in the performing arts? How does this affect the quality of the work and the efficacy of the system? Will the world be a sadder place because theatre artists abandon the stage for Hollywood and TV soaps? What about the classical artist who thrives in an acting ensemble and eschews work in commercials and TV? Is there a place in the world for him? Artisans and craftspersons must have asked themselves these questions with the beginning of the Industrial Revolution. They must have asked, "How will I fit into the future society?" Now we must ask ourselves how theatre artists will "belong" in 2001. Will there be theatre as we know it? Will our acting techniques be outmoded?

Already too much attention has been spent on technological gimmicks in the theatre. Does flooding the floor of a stage space make the dance better? Is *new* always better? Is the person who cannot operate a computer obsolete? When Martha Graham threw out the turnout in dance, she revolutionized dance movement, and the effects of the Graham revolution are still felt in every dance school, in every dance program, by every dancer, aspiring or accomplished—whether pro- or con-Graham technique. Yet Martha Graham's basic inspirations were taken from indigenous folk dancers of the Third World. Did Graham give us something new, or did she rediscover and reinterpret something primeval?

In the next ten or fifteen years, change is certain to come. Let us hope that we can meet the challenges of change by re-examining, reaffirming, and reconnecting with the artistic imperatives that impelled us to become artists in the first place.

15

**BY PHILLIP ESPARZA
AND JERRY YOSHITOMI**

THE
NEW
AMERICAN
AUDIENCE

YOSHITOMI: Many things about producing theatre in Los Angeles are different from producing theatre in other parts of the country. Even within the Los Angeles community, our experiences at the Japanese American Cultural Center will differ in many ways from what Mr. Esparza has experienced with El Teatro Campesino. Yet both of us are working with multicultural audiences, and I think that from an examination of what our two companies have done here, we can construct a useful model for people who are attempting to do similar work in other areas.

Phil, with the productions you've mounted in Los Angeles— *Zoot Suit* at the Mark Taper Forum and now *I Don't Have to Show You No Stinking Badges* at the Los Angeles Theatre Center—what are some of the things you've learned about reaching your audiences?

ESPARZA: One of the most important lessons is to study the situation. Los Angeles is different. California is different. In L.A., a large segment of the population is Hispanic—both English-speaking and non-English-speaking. You have to identify who is in your community so you can set up realistic ways to reach them.

YOSHITOMI: This new audience, this Third World minority— are these the people you are trying to reach?

ESPARZA: We're going after a fifty-fifty mix: fifty percent traditional, mainstream theatregoers and fifty percent non-traditional, minority theatregoers. Here in Los Angeles, half of the latter would be Hispanic. This non-traditional audience is second- and third-generation American, an emerging middle class who see themselves as Americans.

YOSHITOMI: This is also true of the Asian community in Los Angeles.

ESPARZA: There is definitely an audience out there for our work— a new, emerging, Third World audience that has never before been catered to. The hunger for theatre in this community—theatre *for* the community—is so great that even material only fair in quality gets an unbelievable response if it is properly packaged. What people are offered now is shoddy. They're being charged top dollar for less than first-class entertainment. The presenters know that these hungry audiences will take whatever they're offered, as long as it's something to which they can relate—the images, ideas, and music of their background. The desire for this is very strong.

YOSHITOMI: Also, going to a live performance is not foreign to them, although they may not have gone to a theatre before.

ESPARZA: That's right, it's in our tradition. Our grandparents were always taking us to live performances; whether it was the Jamaica [a Mexican social gathering], dances, or other events, the custom of going to live performances has always been present. What's new is that now it's theatre. One of the big attractions that brings our audiences to El Teatro Campesino is the pride they take in attending a theatrical event.

YOSHITOMI: But you have to reach them and let them know that what you're doing is for them.

ESPARZA: Yes. The ad for *Badges* in the *Times* stands out because it's not like the rest of the advertisements.

YOSHITOMI: It's an ad for an ethnic audience.

ESPARZA: Yes, and it's done on a first-class level. Pride is very important—our pride in the way we present ourselves, the pride our audiences feel in attending. We're saying, "We've arrived." It's the American Dream realized. I see it every night in the way our audiences dress; going to the theatre is a big deal. This pride is an intangible thing that swings in our favor: *la gente* [the community] is not going to let us down—as long as they know about what we're doing.

YOSHITOMI: But isn't that a problem—getting the word out?

ESPARZA: Unfortunately, we live in a TV society, and TV

is so expensive. If we could afford even a little television advertising, we could sell out *Badges* every night. But we can't. So we have to find creative ways to achieve visibility. I use groups.

YOSHITOMI: You mean the social, political, and artistic groups in the community?

ESPARZA: Yes. Every community has them. And there are groups in the colleges and high schools, too. So when someone asks me to help out the Boys Club or the Boy Scouts or the juvenile hall by providing free tickets or discounts on tickets, I say yes. You give the group a good experience, and it's good for the community, it's good press, and it plants the seeds for a future audience. It pays for itself, and it cuts down on empty seats. It means more work, but it also means more satisfaction. I can't overstress the necessity of having your community involved in your theatre.

YOSHITOMI: The level of trust and rapport you have with your audience amazes me.

ESPARZA: It comes from networking with these groups. Maybe 50,000 came to see *Zoot Suit*, what with all the student groups and others. Now, years later, many of those kids are coming back because they remember us. As adults they are paying full fare, and in a few years they will bring their families.

YOSHITOMI: It's also important that *you*, the executive producer of El Teatro Campesino, are going to these groups rather than sending a salesperson who has no experience in that ethnic community.

ESPARZA: That's right. What you are talking about is sensitivity. One thing I've had to learn, from the farm workers, is the ability to read who you are talking to. Just because people can converse in English doesn't mean they feel comfortable. I will offer to speak in Spanish, and that's all it takes for them to realize that I'm trying to reach them halfway. And I don't operate on assumptions; I ask questions. Just because people have the money to pay full-price for tickets doesn't mean they can do so comfortably. If I can show them a way to save a little money, they will appreciate that. They will come back again and again. That is where trust begins.

YOSHITOMI: The rapport you have with the Los Angeles audience is even more amazing considering that El Teatro is not based there. Yet you have had two tremendous hits in L.A., mainly because of the response of these groups and this potential audience that no one else is tapping. You have much more contact

with this audience than do the established theatres that have been based in Los Angeles for years. I assume this is because you go out and work with them.

ESPARZA: Yes, but in order to do that you have to know the people. You have to know what they value. Our community is strongly family oriented, so you make allowances for that. The Los Angeles Theatre Center has child care on certain nights, and that is a step in the right direction, but you have to take it much further. Matinees should be family oriented. Sundays are traditionally family day, so we educate our staff that matinees are to be run differently from other performances.

YOSHITOMI: The traditional theatre is not used to having families in the audience.

ESPARZA: That's right, and that's bad business when you consider that people feel comfortable taking their families to other events. Also, our families traditionally tend to be larger. To introduce them to theatre we should have family discounts.

YOSHITOMI: A lot of this has to do with flexibility, with using fresh approaches geared specifically to the new audiences you are trying to reach. Many box offices will not deal with various rates, but they are essential in promoting to a new audience. You can't simply treat it as a special event for a special audience and price every seat at eight dollars. You must have a top price that tells the traditional theatregoer that the event is of value, and you must have discounts and group rates so that the emerging, non-traditional audience can attend.

ESPARZA: Working with the Shuberts on Broadway, I learned that all you need is the right formula. You don't have to have rigid prices. You can have as much flexibility as you need to sell the tickets. And with computerized systems, it's a snap.

YOSHITOMI: We have to be aware that we are dealing with two different audiences—minorities who are not used to going to a theatre per se, and mainstream theatregoers who are not used to attending an "ethnic" production.

ESPARZA: That's why the Teatro is working in collaboration with theatres that have subscription series, because this encourages traditional theatregoers to attend our works. With a season ticket, the subscriber will say, "I don't know who Valdez is or who this Japanese-American artist is, but I've already paid, so I might as well go." Once they are there and they see the Latinos, Asians, and blacks really responding to theatre, the traditional theatregoer becomes a part of the event, too.

YOSHITOMI: That tremendous response that minority groups

give to a piece in which they can recognize themselves is only natural. They grow up with their parents or grandparents fighting to be part of America, and then they see themselves on a stage, in America. If you grow up in an Asian-American community in California, there'll be Hispanics down the street and blacks around the corner, and this is true of most major American cities. The "ethnic" play is not far from anyone in this country.

ESPARZA: In theatre, you have to have a relationship with your audience: Ask them what they think, what they want to see. *Badges* is our response to the Hispanic community's desire— which we became aware of over the last three years—to see something contemporary that does not show images of "Cholos," "Pachucos," and illegal aliens—the usual stereotypes. That's why I knew from the first draft that *I Don't Have to Show You No Stinking Badges* was going to hit. I knew it was going to strike a chord among the people of this community.

You can see how strongly the audience responds to the play. When a traditional theatregoer attends and sees an entire community embracing and applauding what they see on stage, the traditional theatregoer is drawn to it, too. I believe it's unusual for them to see such a direct relationship between audience and play.

YOSHITOMI: *Badges* has received such an overwhelming response from the Third World community because they are seeing images of themselves as Americans. This is very important. A lot of companies, because of special grant funds, decide they are going to reach a minority audience. The product they choose to present does not relate to twentieth-century America, but ostensibly it does relate to the minority group—because it's a classic of their ethnic culture, say. The company hires audience development people, takes out ads in ethnic papers, and even gives out free tickets. But it doesn't work. After a couple of projects like this, the company washes its hands of us. They say, "We've tried with the Asian community, and we've tried with the black community, but they just don't respond."

ESPARZA: And so fifty percent of this audience is not being tapped. It's a tremendous market, but someone is going to have to take some chances in order to reach it. Even in Los Angeles, which is the model for this kind of outreach, the problem still exists. Just look at the repertory of the resident theatres.

YOSHITOMI: And how many Asian, black, or Hispanic artists are working with those companies?

ESPARZA: The resident theatres should realize that it's good

business to cater to these groups. Opening up their facilities once or twice a year for these "special" audiences is just a token. And a lot of people take offense at this: "I don't want to go down there with a sombrero. That's not me."

YOSHITOMI: Giving us the occasional auxiliary event, or meeting grant requirements with audience-outreach programs that have no effect on programing, or relegating us to the second stage—these things do not convey a message of welcome.

ESPARZA: No, we're talking about a new middle class. These people are sophisticated. They know exactly what those things mean.

YOSHITOMI: Our artists have to be on mainstage. And our audience has to be watching that mainstage.

16

BY MICHALANN HOBSON

A MARKETING MANIFESTO

Ten years ago to the day practically, I was honored to be asked to speak to this very conference. After spending a good eight hours throwing up in the toilet, I took my place behind the podium and whispered for forty-five minutes on the how-to's of subscription campaigns. I concluded with the statement that our success at McCarter Theatre was due to the fact that we had Michael Kahn as artistic director. I believed it then and I believe it to this day.

The only credit I could ever take was on the basis of whether or not I had maximized the money I spent, and whether or not I had evaluated the process thoroughly enough so that each year I could improve on the previous one. That was all—no more, no less. (Today I would take credit for selling *Michael* and not wine on the front of my marketing pieces, but since yuppies hadn't been invented then, I wasn't tempted!)

Ultimately, "word of mouth" is what sells a company, and marketing has little control over that. Thus, "marketing" cannot take the credit for things when they work, only when they don't!

In 1980 I wrote the following:

> If at some point performance is an aspect of the creative process, the spectator—by his active response—completes the cycle. When the spectator is also needed to help pay for the process, his or her

participation becomes a critical economic factor. The interaction between artist and spectator becomes a business endeavor, and someone is charged with "finding" the spectators and their dollars: the earned income.

The increased economic need for spectators can be seen in the development of those charged with finding spectators—which has ranged from the artists themselves to the current proliferation of directors of press, promotion, audience development, community relations, and now marketing. Methodology has kept pace accordingly and is well documented with a variety of "how-to" books, pamphlets, guidelines, courses, and seminars on marketing the arts.

And they have been successful. Robert Moss of Playwrights Horizons, upon returning from a thirty-day TCG Observership across the U.S., noted, "The subscription brochure has triumphed. . .the vision of the marketing director is being amply and richly rewarded."[1] At the same time, he spoke of a waning of artistic excitement and felt a decreasing "sense of discovery" on the part of the artists.

And so I find the earned income problem today not as much a question of *how*, but the lack of questioning *why* and *what*. Donal Henahan noted in *The New York Times*, "The managerial revolution in the arts, recently growing so evident, has deep roots in this country, which has always prized organizational ability over the creative impulse."[2]

It is not, obviously, a case for "no organization." The quest for formulas is so strong, however, that the very qualities which are needed to maintain the balance between merchandising the arts without marketing them into an inflexible corner are being overlooked.

I went on to define a planning outline and concluded with:

I would like to suggest that we run the risk of losing the original concept of developing audiences and helping them grow, differentiate, and evolve with our artists if we think only in terms of corralling ticket buyers. The fight is no longer to recognize the need for sound marketing programs in the arts. What we

do have to fight for and remember is *what* we are marketing. We must learn new methods, re-evaluate the old, select carefully, plan in detail. At the same time, we must *not* relinquish the unique identity of our own institutions, our own special products, our own artists. A great deal can be lost if the process becomes more important than the product.[3]

I repeat all of this because for me these concepts have not changed; if anything, I feel more strongly about them today.

With the continuing financial crisis hitting arts organizations, the temptation and pressure to increase attendance blindly is becoming irresistible. Because of all the ongoing expenses, maintaining audiences requires long-range investment. This is in even greater jeopardy than before, and it will be done at even greater risk. But the risk must be taken.

A 1965 Rockefeller Panel Report on the future of the performing arts noted:

Perhaps most important of all, both the creative artist and the performing artist need an intelligent and understanding audience. If an audience cannot appreciate the magnificent and continuing dialogue that makes the artist relate to the present as well as the past, then there is little hope that a work of art will arouse the sense of drama and conflict without which art ceases to be a living, vital matter and deteriorates to something merely "appreciated." When this occurs, art becomes the creature of empty fashion, blown by the artificial winds of publicity.[4]

Twenty years later, where are we?

I feel we have left the central issue of audience development behind, and we have left with it a sense of logic, guts, intuition, and observation. Furthermore, in our zeal to be like corporateland, we have bought into some of their most obsolete models and mistakes. And today, we face with them an increase in competition and communication which is not comparable to twenty or even ten years ago.

Is all of this merely my keen sense of the obvious? Do we all know this, and are we already working to correct these problems? Then why—when we are more vulnerable than ever before—are we still holding on to the same old methods of selling, packaging, and promotion? (Just in case you think corporateland is not being questioned about these same issues, I recommend the book *Positioning: The Battle for Your Mind*.)

I think one of the reasons we have ended up where we are is that we just *let* it happen, by accident. We didn't stop and make conscious decisions at each point along the way. I have always described this phenomenon as a lack of planning, but in so doing I did not give the proper emphasis to stopping whatever we were doing, which is probably the more operative factor. Real planning requires *a special kind* of time, objectivity, imagination, honest evaluation, meaningful projection—an understanding of the true goals of the artists whom we are supporting and the community in which we wish or hope to have that support returned.

For me, this lack of *real* planning has resulted in several major administrative concerns:

- The day-to-day crisis mentality continues unchecked.
- With year-to-year, uncontrolled expansion—artistic and administrative—we are attempting to do too many things with limited budgets and limited manpower, instead of choosing to do a few things well.
- More recently, we are giving way to a tremendous lack of accountability at all levels of our organizations. We're letting people off the hook because they are putting out fires—and spending fifteen hours a day doing it. How can we ask them to do more? If we can't, then we must organize better and make more "appropriate" demands on them.

More specifically in the marketing area, lack of planning has resulted in:

- Constant changing of promotional materials as we attempt to achieve a new look for the new show or the new season— without ever letting the old look take hold. The result? No image, no consistency, no public identity.
- Seduction by quick-sales techniques, without a careful consideration of the long-term results, particularly the attrition which is inevitable if the need for careful nurturing of new users is not understood.
- The blind application of images and techniques which have worked for other organizations, with no understanding of *why* they worked and why they might *not* work for a different organization in a different place at a different time. My favorite example of this: all of us have a file with our favorite brochures from other organizations, and it's a very active file—so much so that subscription brochures have now become the centerpieces of institutional development. Often the artists cling to them as tenaciously, if not more so, than the marketing director. Why

have these wretched pieces—with little or no meaning, often copied from others far away—come to represent the heart of our own artists' work?

● And finally, the latest trap: to be up on technology. Computer junkies are alive and well and living in artsland, too, and because of the *lack* of planning, in any given institution many thousands of dollars are being wasted on the wrong hardware, the wrong software, the wrong applications.

Our situation becomes even more urgent when we look beyond the internal chaos to the sweeping changes taking place in the world outside our doors. We must understand them and come to terms with them, and this will require extensive *research*—another component of planning that we cannot afford to ignore.

In order to be able to plan—and, more importantly, to accept and take advantage of change—we must first get our internal organizational structure in order. That structure must inevitably include what we have come to call the marketing and development departments. Too often they are set up separately. In my opinion, they should be considered together, with joint responsibility for developing an institutional plan for responding to the various defined publics.

As organizations grow, within tight budgets and with limited manpower, we can ill afford structures in which the right hand does not know what the left hand is doing. I agree totally with Sam Miller: we have to get them working together.

I am constantly re-examining marketing tools, which, as tools, are useful only if they are used properly. This means taking time to learn how to use them, and taking time to decide how they can best be applied to specific tasks. Our marketing tools are as vulnerable as anything else to the craving for the quick fix. To illustrate this point, I am going to consider three of them: computerization, telemarketing, and market research.

COMPUTERIZATION

For marketing and development, lists are our life line. The ability to maintain up-to-date lists—not only names and addresses but the entire history of our patrons' relationships with us—is critical. The number of organizations who have transferred that precious information to inadequate software running on inadequate hardware is shocking and scary to me.

Far too many of us have been all too willing to assume that computers would do magic for us, that they would solve problems which we had never been able to solve manually, or had never

taken the time to solve. In some cases, where a problem *had* been solved in our manual operations, we neglected to make certain our automated system was capable of processing our solution.

I suggest that, with computers as with anything else, the cheap way, the quick way, is seldom the best way; it can be disastrous. The system has to be able to do what you want to do, the way you want to do it. Computerization is a process; it demands planning and research. But this need not be as time-consuming as it once was, because many, if not most, of your colleagues have already been through it. Call them before you take the leap.

And don't assume that our national service organizations are promoting the best system. Ask at least three users of that system (or any other) exactly what their experience has been.

This technology can indeed be very useful to us, but in many cases it has meant a tremendous, and needless, drain in man hours and dollars because it has only been taken halfway. With subscription bases dwindling across the country, and a clear need for a review of models and methods of selling, we had better not expect them to come out of machines filled with old, "dirty" data, or new data to which we can't get access.

TELEMARKETING

Many have flocked to telemarketing as if it was sent from heaven to solve all our problems—as if the phone was invented yesterday. For many, the telemarketing campaign has become *the* campaign, not just one, carefully thought-out element in *a* campaign.

Until recently, assuming that folks were catching on, I had started to cool down a little about telemarketing. Then I learned of an arts organization in a major city that had just purchased a Telecall system—for a smart $100,000—which automatically dials lists from tapes, gives a recorded message to the person who answers, and then signals a real, live human being to come on the line and make the pitch. When all the lines are busy, the machine does not necessarily stop dialing. It simply concludes its recorded message with the request, "Please hold," and puts Muzak on the line. Telecall cannot trace and hold callbacks, and there is no access to the machine for processing while calls are being made. Perhaps these are only minor kinks, and perhaps many of them can be fixed. Or perhaps the $100,000 could have been better spent elsewhere.

Telemarketing is the perfect example of the desperate search for quick solutions, without regard to long-term consequences. Just in case I might persuade one person, one organization, not to rush headlong and ill-prepared into this tyranny, let me point out that there is going to be a price to pay:

• When a telemarketing campaign is conducted with little regard for precisely what is being said about the organization and its programs, by uninformed callers presenting themselves as official representatives;

• When there is little or no merging and purging of lists and people are called five or six times, many of them having already purchased tickets or contributed;

• When the marketing survey potential of each call is being wasted because callers are not instructed to ask and record why people do or do not respond to an offer, information which would add mere seconds to telemarketing calls and which costs thousands of dollars to gather in separate surveys;

• When there is no maintenance program for those who do respond, so that the attrition rate, which is always high for telemarketing, is further increased.

Beware of the success stories. There are hidden costs that are rarely attributed to the telemarketing budget. Attrition is one of those costs (it's even more expensive if, instead of using volunteers, you've been *paying* callers), and attrition doesn't show up, at least eighteen months. Furthermore, few organizations are tracking any of it.

Remember, telemarketing is not new. Twenty years ago, Danny Newman had volunteers by the hundreds on the phones, volunteers who were committed to their organization, cared about it, and understood it. This was one of the many sales tools Danny used; he never relied on just one.

And let's face it, telemarketing will have an even more limited life span if we inundate the public with it. We have already seen this happen to direct mail. Both mail and phone campaigns can be made to work if they are used judiciously, if they are planned and conducted with great care, if the market is carefully targeted, and if individuals are properly addressed as individuals. If we do not treat use these tools with respect, we will render them useless. Then where will we turn?

RESEARCH

Few organizations have made a concerted effort—with out-of-the-ordinary programming or marketing—to reach beyond the

universe of "normal" arts patrons. Unless you have done so, more than likely your audience profile will match the national profiles that have been studied many times. You can learn a great deal about your audience simply by reading *Americans and the Arts*, a survey conducted by Louis Harris and Associates.

For the money which most organizations can afford, commissioned surveys of the home market will provide very little more information than the organization can collect for itself. Plan, take time, and be meticulous in researching your community. Begin by studying and profiling your current patrons. You know more than you think you do, especially if you have their names and addresses.

Do not be seduced by surveys based on broad samples, or by purportedly "new" applications. VALS (Values and Lifestyles program), for example, which may be new to some of us, had been around in corporateland for quite a while before ACUCAA applied it to the arts in a special study in 1984.

The ACUCAA study states that the utility of the findings is greatest for administrators of the performing arts who are seeking to design customer-service programs, to uncover means of defining target markets, or to develop more appropriate messages or themes and isolate the specific media through which to communicate more effectively with target audiences. These are worthy goals, and certainly the lackluster and uninformative materials coming out of most arts organizations are proof of the critical need for better communication skills. But dry, humorless, and unfocused copy and design result as much from uneducated interpretations of our own product as from lack of knowledge about target audiences, which VALS or any other system is supposed to address.

Whether arts organizations want to design "customer-sensitive" (a euphemism for "popular"?) programs or are trying to find the appropriate market for programs they know will appeal only to a limited audience, the easiest way to determine what people will buy is to track what they *are* buying. And if it is true that the more often a person attends the performing arts, the more likely he or she will be to increase attendance (which all the research, including VALS, indicates), then why isn't every box office in the country taking down the names and addresses of every single-ticket purchaser every time they buy? The primary market is slipping through our fingers, and the secondary market—their friends and colleagues—right behind them. No survey is needed. And no decent survey will

be possible without these names and addresses and buying patterns.

It's not a question of no marketing being attempted. Hundreds of thousands of dollars are being spent each year to sell the arts in any given city. But few of us know what's working, why, and whether or not it is really cost-effective.

The solutions to our marketing problems are not going to be found by breaking down the middle class into nifty little psychographic cluster groups. So what if only seven percent of your city's population falls into the "Societally Conscious" category and the national figure is twelve percent? There are nine VALS categories, and "Societally Conscious" is one of the seven that together constitute the potential universe of arts-goers. But because the ACUCAA study found an indistinguishable overlap among the four categories on which it focused, it would seem unwise to target any one of them specifically. So we're back where we started, "sloshing around with the same old group," as Ruby Lerner would say.

We should leave VALS to the corporate sector. They can afford to fool around with it and find out later that it might not be all that worthwhile. If they *do* learn something new, we'll see if it applies to the arts.

I do have one "solution" for your consideration. I see few attempting it, but it applies to all arts organizations: it is *cooperation* among all the organizations in any given city. We all have the same needs and the same problems, and we will more effectively meet them and solve them through a combining of resources.

Take just one of the three items I have discussed—telemarketing, computerization, or market analysis—and take any city with several arts organizations. You'll find repetitive dollars being spent to get the same information. These overlapping expenditures are not enhancing the various art forms; nor are they being used efficiently to find or develop audiences. These are dollars wasted.

Another area of potential cooperation is mailing list maintenance. If everybody's information about current arts users were combined and researched, critical data and money would be available to cultivate and program for non-users. Yet another area that would benefit is advertising—combination ads in regional and national media, as well as shared local advertising for greater visibility. The list goes on and on.

Internally, we are inundated with choices about how to market

the arts; externally, people are inundated with choices about how and where to spend their time and money. Because of this, our marketing and audience development efforts require more planning and more care than ever before.

Frank Galati, associate artistic director at the Goodman Theatre in Chicago, noted in a recent interview:

> In the past there have been occasions where production values have swamped a play, or a play has been too cumbersome intellectually to delight and divert its audiences. Theatre can crumble under its own weight.
>
> On the other hand, one can do an outrageous theatrical production in a storefront, and just dazzle everyone by the sheer overcoming of insurmountable obstacles. One often forgets how insurmountable an obstacle a big budget can be, a big theatre can be, a lot of scenery can be. They can actually be harder to deal with, and harder to succeed with, than a couple of planks and a passion.[5]

At least, let us not forget the passion amidst all these planks.

Footnotes

[1] Theatre Communications Group Newsletter, June, 1979.

[2] *The New York Times*, March 18, 1979.

[3] "Earned Income: Dollars & Sense," *Theatre Crafts*, Jan./Feb., 1980.

[4] *The Performing Arts Problems & Prospects*, McGraw-Hill, New York, 1965.

[5] "Galati's Newest Hat," *American Theatre*, Theatre Communications Group, March, 1986.

17

A LATE-
TWENTIETH-
CENTURY
DREAM

I want to risk being completely foolish and offer up this particular dream. It is not, unfortunately, what I actually see happening in the future, but what I would like to see. I don't proclaim it to be *the* grand new vision, just a teeny little vision. I'll put what I have to say in the framework of theatre, which is what I know best, and I'll put myself in the audience.

In the main, I find that I'm increasingly less excited by theatre, particularly institutional theatre, particularly "plays." The more well-made, the less interested I find myself.

When I want to be entertained, I go out to eat or have friends over for dinner. Or I rent two movies for my VCR for $4.50, which is much cheaper than most performances, even those at small theatres. Or I play with the wonderful graphics program and the 512-color palette on my Atari 520 ST computer. Or I read a book. Or I go see Dominique Wilkins and Spud Webb play basketball—now *that's* art, *and* you get to eat terrible hot dogs, drink beer, and shout obscenities at Danny Ainge.

I don't mean to sound flippant. I've been trying desperately to understand why I—a theatre professional, a lover of theatre, an erstwhile performer—why I am losing interest. Are other people, people who don't work in the arts but whom we count on for their interest and support, also losing interest? What

about those who weren't even interested in the first place? Why is most of what I see so removed from my personal concerns? Why has so much work in the arts lately seemed passionless to me? Why does so much of it reflect that "fashionable ennui" that Richard Louv referred to, in style and in content.

If we honestly assess our organizations, we must conclude that their role is not integral to the lives of our communities; they are not true centers for our communities. What we have cultivated to date, some of us more successfully than others, are relationships with individuals of relative wealth (audiences and boards), dead individuals of wealth (foundations), and the business community. These relationships are motivated by our very real monetary needs. But I wonder if our close alignment with this small but powerful sector of the community may have limited and skewed what our organizations might become— in fact, may have been partly responsible for keeping away from our doors those new audiences that we all talk about and crave.

Our work has been reduced to a commodity—good for business, decoration for Chamber of Commerce brochures. And in creating this work, in promulgating and foisting our individual tastes on our communities—with the expectation that our work will be met with magnanimity—we have been insular, isolated, and self-centered.

I find myself getting very nervous whenever I hear talk about the vision of the artist, which assumes that our private, idiosyncratic visions are worthy of support. This is derived from the myth and, I suggest, the long-outmoded concept of the artist as someone who has been especially chosen, someone blessed from above with the gifts of divine wisdom and insight, and someone for whom alienation from the rest of society is an added and necessary burden. Yet vision, in the limited number of places I see it, grows out of a synthesis of very worldly, down-to-earth processes: training, life experience, imagination, observation, reading and study, and discipline.

We talk about partnerships with boards and with audiences, but we don't really mean partnerships. We mean getting as many people as possible to support us so that we can do exactly what we want to do. There is a problem with this kind of partnership, and I think *we* may be the problem.

Sometimes I can see a faint glimmer of a new kind of artist and a new kind of organization. Yesterday, Bob Olson's closing quotation from Fred Polak about the role of artists in stimulating the "social imagination" really hit me. I've become very interested

in the possibility of arts organizations serving as community healers, problem-solvers (or at least problem-grapplers), and celebrators.

Look at the problems that need solving that we, perhaps, could help solve. There is certainly no shortage: racism, sexism, classism, imperialism, toxic waste, plant closings, the new poverty, homelessness, child abuse, drug abuse, teen suicide, the ethical and moral dilemmas posed by technology—the list is endless. What if we focused the collective creative energies of America's arts community on the dissection of these and other problems in our local communities, in the nation, in the world? Could we create new work to address these issues, dig up relevant older work and classics, perhaps uncover work that was unpopular in its own day precisely because it attempted to deal with these same issues? What if we were to dissect and celebrate local history or events in world history as seen, as experienced, by members of our communities? What if we were to look at the fears that surround the new privatization of the middle class, help illuminate the "false communities" that Richard Louv described, and help envision what shape truer communities might take?

What I do *not* mean is this: Let's commission a play about child abuse for our three thousand white, middle-class subscribers and have a post-performance discussion conducted by a psychologist. Rather, let's enter into a true partnership with others working to solve this problem—social service agencies, psychologists, law enforcement officials, and other professionals. Let's find out what *they* need from *us* in order to illuminate this issue—and others. In other words, let's begin to see ourselves as being in service to the needs and desires (perhaps even the hidden desires) of the community.

This is quite different from the situation now, in which we decide *for* the community what it needs and desires, then are surprised and hurt when the community doesn't agree with our assessment. What if we set our agenda *with* the community? The difference between *for* and *with* would require a quantum leap in thought.

What I would really like is for the arts community to say, "Let's try to understand racism and sexism and classism and some of the other serious issues confronting our community and our society today. Let's investigate these problems with others in the community. Let's make dances, murals, performance art, poems, film and video that illuminate our

investigations. Let's help "reveal the community to itself,'" as Richard Louv suggested.

Could we then hope to provide those "inspiring images that precede new realities," to which Polak referred? Wouldn't this kind of work begin to address that hunger for real, not fake, community? The key here is that the work would not grow out of our isolated imaginations but out of the collective imagination of the people in our communities—communities of which we are a part, but not the only part.

I know there is a fear that this process might not produce "great art." It's true that those artists and arts organizations who have attempted collaboration with their communities have often spent their time fumbling around for a process—with quite mixed results from a critical perspective. But given refocused artist training, anything might be possible artistically.

We might also become *animators* for others in the community by satisfying and further stimulating their desire for greater participation, by helping people to address the gap between "lifestyle" and "values" that plagues our generation. I think that a society that is solely a spectator society could be viewed as "ill." Just as there is new thinking about preventive medicine and wellness, perhaps we must begin to think about meaningful participatory cultural activities as a kind of "cultural wellness." More and more people are beginning to participate in amateur sports and in their own health care. Why should the cultural arena be exempt?

This challenges our notions of what it means to be a professional artist in the traditional sense. It would require tremendous alterations in the way artists are trained: we would need to discourage what, in the theatre, I call the "my instrument, my agent, my career" syndrome; we would need to encourage ensemble thinking, community development and urban planning skills, collective creation, and a more holistic and less self-centered value system.

What I am thinking about would require a total transformation in our thinking, in our training, and in our organizations. It would mean working both with other arts organizations and, even more important, with non-arts organizations toward common goals. It would mean creating true partnerships. In so doing, I think we would find our appropriate size, our appropriate structures, and our art and arts organizations would be "re-personalized." We would no longer be separate from the concerns of our communities and our audiences because we

would be attempting to address their, and our, secret fears and desires and their "longing for home." Then at last we might have a leadership role in our communities.

PART VI

OBSERVERS' REPORTS

18

BY JAMES F. HINCHEY

CONFESSIONS OF AN URBAN DIVINE

I bet nobody's ever before been to a conference where one of the program planners brought his parish priest for protection.

A homiletics professor of mine once said that a good preacher ought not to preach what other people need to hear, but to engage in a shared meditation with those who are willing to listen and to preach what he himself needs to hear. That's what I'd like to do. I've been tremendously nourished and nurtured by this experience, and I've been made aware of how important a conference on change would be for the clergy—myself included.

These past few days, I've noticed remarkable parallels between the theme of this conference and what I perceive to be happening within the Roman Catholic Church. I suspect from my own visceral response to the challenge of change that a gap exists between our intellectual recognition of the inevitability of change and our ability to cope with the sometimes staggering implications of change. It seems to me no less a struggle for writers, dancers, composers, actors, choreographers, musicians, artistic directors, producer-managers, marketing and development personnel, and boards of directors than it is for pontiffs, cardinals, bishops, priests, monks, nuns, and the laity— the church's indispensable audience in the pews.

The dilemma for someone like myself is that I still tend to resist or flee from change that is unsettling and that threatens

to turn my tenuously secure world and my most cherished preconceptions inside out or upside down. Despite my enormous capacity (or so I have convinced myself) for flexibility and resilience, I find myself wanting change to occur on my terms. Thus I'm inclined to regard change and the challenges it presents in illusory and often self-deceiving ways:

1. Change—and I'm talking about organic or integral change, not cosmetic change—is something usually required of others.

2. Institutional change is something that should transform those organizations and social constructs which impinge upon my freedom and ability to do what otherwise I know I could do brilliantly.

3. If there is to be significant change in my life or in the life of the organization with which I most closely identify—and right now that happens to be St. James Cathedral Parish in Brooklyn—then I want to initiate it and control its course. This, after all, I tell myself, is the role of visionaries like ourselves.

That bit of confessional matter out in the open, I have to admit that during these few days I have been startled to discover the extent of this disparity between what my head knows and what my guts fight to deny. I say this as one who is frequently dismayed by the unwillingness of others to accept growth-enhancing, life-affirming change. And I say this as one who is frustrated by the "virus of distrust" that afflicts familiar, venerable, cherished institutions when confronted with the challenge of significant change.

I just happened to look at our diocesan newspaper yesterday and I saw a little statistical survey regarding seminary enrollment in the United States—and I think the trend applies to theatres and audiences as well. The number of Catholic seminarians in the United States dropped 4 percent from 1985-86 to 1986-87. That doesn't sound too bad. However, the newest figure represents a 43 percent decline in the past decade and a 76 percent decline over the past twenty years. That's a little more unsettling. To show you how poorly we cope with this, there are three major Roman Catholic Theologates in the greater New York area with drastically reduced numbers of students and under-utilized faculties and facilities, yet nobody wants to give up their tour. And my fear is that change will simply be forced upon those institutions and that they will not creatively participate in finding life-enhancing, life-affirming solutions.

Again, there seem to be tremendous parallels between this situation and much of what has been discussed at this conference.

I would also like to share with you something I found happening in myself. When I went to St. James Cathedral almost ten years ago, it was a kind of wasteland—an urban warehouse with about seventy-five parishioners. Now we serve over five hundred households. In those early days we were much more daring, much more willing to try just about anything. We used to say, in effect, "Just float a balloon, and if it doesn't work, don't worry because other attempts will." Now that we have begun to flourish and prosper, we have much greater proprietary interests in what we are doing, and we feel much more threatened by suggestions of change.

I think I have been helped by the reminder during this conference that at any given time, continuity is always greater than change. Certainly this is true of the religious institution of which I am a part, and it is the best reason for not fearing the developmental change that is often accomplished in the sometimes painful crucible of debate and dissent. At a recent symposium at St. James Cathedral, it was the insight of a prominent Catholic layperson, who also happens to be the Governor of New York, which underscored this point. Alluding to present areas of turmoil within the Church and relating them to the past, Mario Cuomo said, "The early Church was a Church journeying through history, still forming a sense of its identity and mission. Ambiguity, restlessness, incompleteness, an eagerness to probe, to refine, to deepen understanding—none of these caused the gates of hell to prevail against the Church. In fact, they led to a deeper, more vibrant Church."

It has also been helpful to realize that change, if understood and anticipated, is the means to a goal and not the goal itself. Seen as an opportunity and not an obstacle, it enables individuals and institutions to become more fully all that they are capable of becoming. Or to paraphrase something that was said earlier in this conference in a slightly different way: What we are now is only part of what we will become later. The unknown future is only to be feared if we approach it with our heads in the sand of denial and illusion, for the alternative to creatively embracing change is the tomb. As Lord Rothschild asserted, even a virtuous life has risks. Arts institutions and religious communities alike—which have more in common than either may wish to acknowledge—must work to throw off those fears which drive them to seek only risk-free solutions to thorny issues,

which demand adherence to old formulas, which no longer satisfy people's deepest longings, and which dictate conformity to suppositions that have long since ceased to clarify and now only serve to confound.

In imagining a new creative dialogue between the arts and religious communities—and I've been imagining that all weekend—I can foresee once again the possibility of metaphors and experiences that inspire positive images of what human beings can do and of what human communities can be. In theological terms, I envision a felicitous blending of what we call "the already and the not yet." As one who well remembers that this church to which I belong has both fostered and suppressed the arts, has been both a patron of creative enterprise and its fiercest opponent, I'm encouraged to know that many enlightened people in each of these worlds we represent still believe that what inspires and nurtures, what is true and beautiful, cannot be genetically engineered, laser-induced, or mandated under pain of excommunication. Only with arduous effort and tenacity of spirit in a communion of creativity can it be discovered and celebrated.

19

BY JEANNE HOWARD

CHANGING
COURSE

Like Father Hinchey, I'm not a theatre person, although there are theatrical aspects to what I do. As a university teacher in urban planning, I, too, have been struck by the parallels between what has happened in theatre and in my field.

Urban planning in the 1960s was fat city, and we had to beat potential students off with a club. Now our audiences have dropped, and we are taking approaches that people would have thought crazy a few years back. We're also experiencing something that may hit you in a few years: the first leg of the Baby Bust. There just aren't as many eighteen-year-olds as there used to be, so we're developing new audiences among other groups.

So here I am, teaching an urban planning program and dealing with people who are eighteen, twenty, twenty-two years old. They're educated, they're nice, they're bright, and they're hell bent for success. They call themselves yuppy larvae, and they are, in some respects, your future audiences.

Recently I attended a FEDAPT conference at the O'Neill Center, where one of the speakers was Liz Lerman, a wonderful lady from a dance company called the Theatre of the Third Age. She said something that I like: "As far as I'm concerned, artists have something that people want," she said, and I thought, *Yeah*. So I took that home with me to my classes.

I teach a class in the study of the future, and we talk a lot about what there is once you've achieved success—what you really want to be. We talked about that "something" that artists have that people want: a sense of passion, of joy in the doing, a commitment to excellence, a feeling of developing oneself to the fullest, and a sense of exhilaration. My students agreed that these are terrific things that make for a full life and that they wanted to have them. But I was shocked when they identified how they experience that sense of being fully at their best: They go skiing. When I suggested that they might find the same thing in the performing arts, their response was, "We never thought of that." I probed a little bit, and I discovered that for many of them, the model of what the performing arts are about— what you get when you go to the theatre—is the lecture hall. That is, "Come in. Sit down. Hear what the folks are doing for you. Applaud at the end and go away." That's the way they see it, and that worries me.

I'm not a theatre person, but when I heard Liz say, "Artists have something that people want," I thought that I'd like to participate, to partake of that sense of special something. As Richard Louv said, people out there are waiting to be ignited; they're waiting to be illuminated. Is it going to be by those of you here or by a ski resort operator? How do you get your chance to do this? How do you get those audiences?

Let me tell you a story about the hundred monkeys. A group of zoologists went to an island off the coast of Japan where there were a great many monkeys. They decided to test the behavior of the monkeys when a new food was introduced, and they brought in a whole fleet load of yams for them to try. Well, the yams they brought were pretty gritty, and the monkeys didn't like them very much.

But one morning, a young monkey went down to the water and washed her yam off, and she found out that it was delicious once it had been cleaned up a bit. She somehow communicated to the other monkeys about it, and a few days later, more monkeys went down to the water and washed off their yams. Day by day by day, a few more monkeys would go down to the water and try out this new way of doing things.

One morning, the hundredth monkey picked up his yam, went down to the water to wash it off, and for some reason a critical mass was achieved. After that, thousands of other monkeys on the island fell in and went down to try out this better way. Clearly something had happened—some moment of creativity,

a willingness to try a new solution—that triggered all the others.

My notion is that people, like monkeys, will change if a better way is available and if a critical mass will try it out.

But who makes up that "critical mass?" What do our times have in store? How can we respond?

On my way to this conference, I picked up a copy of *The New Yorker*, which had a profile on a historian, a very elderly Scottish gentleman. The interviewer asked him, "What music do you listen to?" and this gentleman replied, "Well, I don't listen to much modern stuff. Beethoven was the beginning and the end because Beethoven was where the bourgeoisie came in."

Now, there may be nothing you would like better than to have the bourgeoisie come in, and the proletariat, too, if you can get them. But I was interested in the idea that Beethoven represented a transition between one era in the arts and another. It reminded me of Alvin Toffler's book, *The Third Wave*, in which he described the shift that the world experienced some two hundred years ago, from being primarily agrarian and monarchical to being more urban, industrialized, and centralized. This shift included some of the structures within which the arts took place. Larger halls, larger performance settings, made it possible for people to consider different artistic forms—including the symphony, which couldn't be done in a small, chamber music setting. I don't know much about music, but I think it's possible that in the early days of these large halls there may have been some very uninteresting pieces of music written for them. But then along came Beethoven, who used these new settings and transformed them with the scale, scope, and intensity of his symphonies.

I've heard some talk at this conference about our becoming a third-wave society—decentralized, ex-urban—and about the new technologies which may make new artistic contributions possible. I'm not sure what's been done to use the ex-urban setting as a focus of the arts, what kind of performance facilities are out there just now. We may have transplanted the urban model to the suburbs, and it might not work. It may be that new, "deconcentrated" structures are needed that take advantage of our new technologies. Or perhaps it's a new sensibility that's required, such as the kind that the author of *Pacific Shift* says is brewing on the West Coast. There, he says, a kind of Buddhist consciousness is starting to influence people's perceptions and may—in combination with technological advances—transform the arts.

My impression from this conference is that there is a readiness to think about change that didn't exist three or four years ago, and that the readiness is more evident than ever before. But like a supertanker when it changes course, there's an awful lot of inertia that has to be overcome before you'll begin to see some action. That's as true in your field as it is anywhere else. Remember, though, that it's during the transition phase that the important work is done, the effort that sets a new course. From what I have heard here, I have no doubt that setting and charting a new course in theatre is about to happen.

20

BY MIKE STEELE

CHANGE IS ALWAYS UPON US

I want to try to tie everything that has been said back into the arts and to share my perception both of the arts and of the changes taking place in them.

I agree that we in the arts have to respond to the changing environment that's upon us, but I don't think we can accomplish that simply by changing management structures. Furthermore, the notion that change is suddenly upon us in 1986 is a misconception. Change is always upon us; good art is always new.

Part of the problem in anticipating the future is that we have a very hard time figuring out the present and interpreting the near past. Television is only thirty-five years old. I went through high school before I even saw television—something which, if you are all under thirty-two, probably seems phenomenal. Yet it is clear that in only thirty-five years, television has had a *profound* impact, not just on audiences, and not just as the competition for leisure time, but in defining and creating a new reality. We're only now beginning to understand what really happened thirty-five years ago.

So I question how many decisions we can make based on what we think is going to happen thirty-five years hence. I see much that's very rich and challenging in the changes we're discussing—things that could make the arts indispensable in

society. At the same time—if I'm reading the subtext of this conference—we're also wondering whether or not our handicraft industry has a purpose in the 21st century. We're in an era when the arts are competing with poverty programs and hospitals and schools for funding. We're in the nuclear age, and the age of nuclear diplomacy. Our world is experiencing enormous changes—overwhelming ones. So how can we justify getting a few hundred people into a room and presenting a play for them? This is especially difficult on the managerial and financial levels, given the usual existential problems of being unable to increase audiences as funding levels off and costs go up.

And there's something else. Increasingly I find people in the arts who say very openly that they don't go to arts performances very much themselves. They're bored. This morning we've heard words like "visionary" and "humanizing," but I don't see much of either when I go to the theatre. I see a lot of actors and playwrights and directors who are hermetically sealed in some style that they discovered twenty years ago and who haven't changed much. I've seen people going to the theatre only to be given a sermon. The Catholic Church learned long ago that you have to be entertaining at the same time that you're sermonizing if you want people to come back.

I also sense a lack of faith and conviction in the arts and a rise in artistic cynicism, which I believe is the most deadening thing in our culture right now. We're not exerting ourselves. We're holding back from becoming a major part of our communities. We're falling all over ourselves, apologizing for what we do and talking in a meek voice. "Can we have a little bit of money to keep surviving, please?" Often that's our tone.

A lot of what we've been talking about at this conference is not change, but the *perception* of change. Change is a very abstract event; it's not a thing, like water in a glass. Change occurs when someone recognizes it as change. That sounds like a semantic point, but it's very important. We've talked about people moving out of our cities into suburban areas that present the illusion of home, the illusion of countryside, the illusion of security. Why? They feel some generalized fear in our urban areas. But are cities really as violent as they believe? Or are they having trouble explaining a certain kind of energy emanating from people—people with whom they have little contact and who aren't the same as themselves? Is that why they feel more secure living in enclaves of people who look and think and act exactly alike?

The implications for the kind of changes our society will experience—and how we perceive them—are startling. So, too, are the implications for our perception of reality. Here we are, back to the impact of television, as every night Dan Rather comes on and interprets reality for us. Of course, Rather is interpreting it from the standpoint of CBS, which has a vested interest in the way we see that reality. Often he's repeating what Ronald Reagan has said that morning. Indirectly, then, Ronald Reagan is defining our existence for us, defining the reality that filters through.

Now the question is this: Can the arts give us an alternative to these and other such sources of our reality? The answer is not just Yes. The answer is that this is precisely what the arts *should* do—*must* do.

I know that this is possible because most of my perception of the world is through the arts. It's through the arts that I am able to grapple daily with the world. And if I go to the theatre and am bored to death, I know that it's probably because what I saw failed to address, in some way, what I read in the newspaper. At least I can recognize that failure. Most people simply pay their money, walk out, and get tanked—or whatever they do.

One of the reasons that theatre gets boring is that our young artists—who come along full of energy and vision and perception—end up having to spend enormous amounts of time trying to keep their institutions afloat. As they burn out, it isn't just their energy that's lost. They begin to get cut off from fresh perceptions of the outside world, and they keep repeating what they've perceived in the past. Eventually they discover that the reality they are expressing is no longer the reality that is, that has *come to be.*

We have to make room for a host of new ideas in the arts. An enormous number of people who formerly had no power in our society are now demanding access through the arts. They're demanding a voice and the chance to define reality as they see it. I'm talking about people who are wrestling for the chance to redefine and reimagine our expectations of the world. I don't know where else they can accomplish this other than in the arts.

The notion of artists becoming directly involved in their community is very important. It would have seemed preposterous even to have to discuss this during the Renaissance, when the artist was designing sewer systems, building cathedrals,

serving in local government, or acting as envoy to a foreign country—all in addition to painting or sculpting. How did we get into the state we're in? How did the arts get so extracted from society?

As soon as we get over the notion of the artist as an angelic being touched by God, someone whose visions of the world are not privy to the average stiff on the street, the better off we'll be. Instead we should be talking about people who look directly at the world and challenge what they see. Once artists think in these terms, once we have this vision for the arts, then we'll better understand how to make them more a part of our society. But getting there requires trying to see the world— in all its variety, with all its changes—more clearly.

EPILOGUE

The months which have passed since FEDAPT's "The Challenge of Change" conference have done nothing to diminish the energy, intensity, and relevance of the presentations made there. If anything, certain events have underscored how rapidly and dramatically our perceptions, plans, and lives can change. Who would have thought, for example, that within six months of the close of the conference on November 9, 1986:

• members of the most popular Administration of our time would be under investigation by a special prosecutor and a Watergate-style committee for possible criminal acts;

• the leading Democratic candidate for the presidency would be forced to withdraw from the race in the wake of accusations of moral deficiency;

• the entire television evangelical movement would suffer a "crisis of faith" as charges of *both* possible criminal acts and moral deficiency shook the foundations.

Even if these and other events have little immediate impact, who can predict what changes they will set in motion, how profound those changes will be, and how long we will feel their effects?

Since the conference, we have continued to examine the changes taking place in our environment and the kinds of responses that may be required of artists and arts organizations to prevail. The following observations describe what we have found and suggest where our inquiry is likely to lead us:

1) The creative drive and the missions of our organizations must come from artists, from the quality of the artistic process, and from the centrality of art. Our thought and work must be directed toward rejecting stereotypes and formulaic solutions. Toward that end, we must develop human and financial resources

that will enable us to achieve our artistic goals and to build adaptive institutions that serve them.

2) Many artists and arts organizations seem to have lost their footing, their sense of balance. They develop programs and structures that fail to serve their art. They compete among themselves for the same narrow audience at a time when the population is segmenting. This abdication of a center has been accelerated by several factors, including the emphasis on growth in size as the primary measure of success; unwarranted faith in the institutional process; and counterproductive pressures from community leaders and funders. Artists and arts administrators must recover their balance and develop the appropriate organizational size, scale, structure, and level of resources to keep it.

3) As more and more leisure-time choices are available to audiences, how can we be assured of their continued participation in what we do? Will they still subscribe to our events and so provide us with a base of earned revenue? Will funders continue to support us? Clearly we need to explore the ways to re-establish personal relationships and communications between artists and arts organizations on the one hand and contributors on the other.

4) The needs of volunteers, including board members, are changing rapidly. The lives of people to whom we look for volunteer services are more and more complex, though they still want to give time to their communities. As a consequence, they are becoming more involved in finite projects that make efficient use of their skills, while finding people to attend meetings year after year and assume responsibility for the overall continuity of an organization becomes increasingly difficult. We must continue to explore the mythology that surrounds the board model and redefine the nature and role of the board of directors and other volunteer groups within an organization.

5) In the rush to satisfy unrealistic expectations for their institutions, many arts professionals have surrendered the discipline, integrity, authority, responsibility, and accountability for their organizations. It is time to re-empower those professionals, to build more appropriate relationships with funders and community leaders, and to put artists back at the center of our arts organizations.

In the introduction to her book *The Aquarian Conspiracy*, so often mentioned during the conference, Marilyn Ferguson

states that using "conspiracy" in the title made her uncomfortable at first. She worried that the negative connotations of the word might hurt the book's appeal. Then she checked its etymology and found that the word's root was "conspirare," meaning "to breathe together" (as huddled conspirators naturally would). She kept her original title.

As we reflect on this conference — on the articulate presentations by speakers and challenging questions and comments from participants — it seems that we are all conspirators. We know that the conference itself has become both an agent for change and a tool for working with it. What more conspiratorial act can there be than to try to anticipate the future and then affect it? What task is more suited to the talents of passionate people?

Thinking together, working together, breathing together, perhaps there is hope that we can conspire successfully and rise to meet the challenge of change.

Ruby Lerner
Nello McDaniel
George Thorn

BIOGRAPHIES

Thomas P. Carney is the president and chief executive officer of both Metatech Corporation and Bioferm, Inc. He was vice-president, research development and control, at Eli Lily and Company, and executive vice president at G. D. Searle before founding his own company. His undergraduate training was in engineering at the University of Notre Dame, and he obtained an M.S. and Ph.D. in chemistry from Pennsylvania State University. He did post doctorate work in medicine at the University of Wisconsin. He is former chairman of the board of trustees of Barat College and has just retired as chairman of the board of the University of Notre Dame. He was one of the founders of the Academy Festival Playhouse in Lake Forest, Illinois. In the last three years he has published two books: *Instant Evolution: We'd Better Get Good At It* and *False Profits: The Decline of Industrial Creativity.*

Tisa Chang was born in Chungking, China. In New York City she was a music major at the High School of Performing Arts and attended Barnard College and City College. She has been a professional theatre person as a dancer and actress for twenty-three years. Ms. Chang has directed at Equity Library Theatre, Lincoln Center Library and Museum of the Performing Arts, The Women's Project at American Place Theatre, and Studio Arena of Buffalo. As a resident director at La Mama ETC, her productions included the ground-breaking bilingual hit, *The Return of the Phoenix*, which was later adapted for CBS-TV. In 1977 she founded Pan Asian Repertory Theatre and has directed nineteen of its productions. As a performer, Ms. Chang has appeared on Broadway, in many films, and most recently participated in Robert Redford's Sundance Film Institute in Utah.

Dudley Cocke is the director of Roadside Theatre. Roadside's home is in the Appalachian coal fields of eastern Kentucky. The theatre's actors and musicians all were born in the region, and for twelve years the ensemble company has been developing original plays drawn from the mountain history and culture of its home. In creating a theatre about a specific place and people, Roadside finds that it speaks to many places and people, especially rural Americans. Roadside is a traveling theatre, touring throughout the U.S. and occasionally to Europe. Mr. Cocke writes, directs, and produces for Roadside. Roadside Theatre is part of a collective that includes Appalshop Films, June Appal Recordings, Headwaters Television, and WMMT-FM Radio. Mr. Cocke presently serves as vice chairman of Appalshop's board of directors.

Leon B. Denmark is the managing director of The Negro Ensemble Company and served as their general manager prior to assuming that position in 1981. He graduated from Columbia University with a B.A. in sociology and did graduate work in arts administration at the State University of New York, Binghamton. He has also served as the executive director of the Rod Rodgers Dance Company and as assistant director of the S.E.E.K. Program at Queens College. Mr. Denmark has worked with a number of arts groups in the New York City area, The Black Theatre Workshop, affiliated with the New Layfayette Theatre Company, in particular.

Phillip Esparza, a core company member of El Teatro Campesino for sixteen years, is a native of the San Joaquin Valley of California. He joined El Teatro in 1969 as an actor and technician, and subsequently became technical director in 1971, company manager in 1972, and tour coordinator in 1974. He served as administrative director from 1976 to 1978. For the stage productions of *Zoot Suit*, he functioned as promotions coordinator and community liaison for both Mark Taper Forum in Los Angeles and the Shubert Organization in New York. In 1981 he was associate producer for the film version of *Zoot Suit*. In 1982, he co-produced the original workshop production of *Los Corridos* in San Juan Bautista, and in 1983 he co-produced the highly successful San Francisco production of *Los Corridos*. He has produced and co-produced many of the productions of El Teatro Campesino since 1979. He was co-producer of the San Diego and Los Angeles production of *Corridos*, and

continues to function as the senior producer of all the major Teatro Campesino productions.

Bernard Gersten has been executive producer of Lincoln Center Theater since 1985. He was formerly the managing director of Alexander H. Cohen Productions and president of Bentwood Television. Prior to that, he served as vice president for production at Radio City Music Hall, where he produced a number of shows. Mr. Gersten has also been the executive vice president of Zoetrope Studios. He was associate producer for New York Shakespeare Festival productions at the Delacorte Theater and on Broadway, for the Beaumont and Newhouse Theaters at Lincoln Center, and for the Public Theater. He is a former president of the American Arts Alliance and a lecturer on theatre administration at New York University.

James F. Hinchey is a priest of the Roman Catholic diocese of Brooklyn and co-rector of St. James Cathedral Basilica. He has been with St. James' for ten years. Before entering the priesthood, Father Hinchey taught for five years at the University of Cincinnati. He holds a doctorate in English Literature with an emphasis on modern British drama from the University of Wisconsin.

Michalann Hobson has been working on a project basis since 1978 as an arts management specialist in the areas of marketing and development campaigns, strategic planning, budgeting, product development, management training, and conference planning. Ms. Hobson was the communications director for the McCarter Theatre in Princeton, New Jersey. She has worked with more than 100 performing arts organizations, including theatre, dance, and opera companies, symphony orchestras, and presenting organizations in twenty-two states and Canada.

Jeanne Howard teaches courses in urban history and in the study of the future at Virginia Polytechnic Institute and State University. Her background is in Russian and Soviet history. She holds a Ph.D. from the University of London. She has worked with FEDAPT and other arts groups for the past five years. She is currently working on a book on urban planning in sub-arctic and arctic areas.

Robert H. Leonard, founder and producing director of The

Road Company in Johnson City, Tennessee, has been exploring improvisation in the theatre as a skill for ensemble development and new-show development for fourteen years. Since 1975, he has directed the development of nineteen new works through ensemble and/or collaborative efforts. A graduate of the College of Letters at Wesleyan University, he studied theatre in the graduate program of Catholic University and worked, in Washington, D.C., at the Garrick Players and the Washington Theater Club. In addition, he is a founding member of the regional organization of Alternate ROOTS and is currently serving on the ROOTS executive committee. He is also treasurer of the Johnson City Area Arts Council.

Ruby Lerner is the former executive director of Alternate ROOTS in Atlanta, Georgia. She also served as audience development director at the Manhattan Theatre Club for four years. Ms. Lerner has been consulting with FEDAPT in the areas of marketing and audience/community development for seven years and co-directed the last two FEDAPT Theatre/Dance Management Institutes on Marketing at the Eugene O'Neill Theatre Center. In addition to winning several awards and memberships on advisory panels, she has published articles in *Vantage Point*, *American Theatre*, *Poor Dancer's Almanac*, and FEDAPT's *Market the Arts!*

Richard Louv is a nationally syndicated columnist with the *San Diego Union* and Copley News Service. He is also the author of *America II*. A futurist and award-winning journalist, Mr. Louv writes a monthly column for *PSA Magazine* and has appeared on numerous television and radio shows, including *Phil Donahue* and *The Today Show*. A graduate of the University of Kansas, he was the director of OPTION, an international recruitment program for medical professionals volunteering in medically underserved areas in the United States and overseas.

Cynthia Mayeda, managing director of the Dayton Hudson Foundation, manages policy formulation and the administration of the corporate and foundation giving programs. She also directs the foundation's grantmaking budget for national organizations and manages the Minnesota Arts budgets. She is currently vice chair of the United Way Overall Allocations Committee and serves on the Program Committee of the Minnesota Council on Foundations. Nationally, Ms. Mayeda

serves on the National Endowment for the Arts Theater Company Panel, the Educational Programs Committee for the Council on Foundations, as well as on the board of Women and Foundations/Corporate Philanthropy. Prior to joining Dayton Hudson, Ms. Mayeda was managing director of the Cricket Theatre in Minneapolis.

Nello McDaniel, executive director of FEDAPT, joined the staff as dance program director in April, 1982. From 1978 to 1981, he managed the Presentation and Touring Programs for the National Endowment for the Arts Dance Program. Prior to that, Mr. McDaniel served as chief operating officer and performing arts services director for the Western States Arts Foundation, a ten-state regional arts consortium based in Denver, Colorado.

Samuel A. Miller is the managing director of Jacob's Pillow Dance Festival and School. He assumed this position in October, 1986, after five years as the manager and director of development for Pilobolus Dance Theatre. Prior to joining Pilobolus, Mr. Miller was director of development at Pennsylvannia Ballet. He serves on the board of Dance/USA as treasurer, and this past summer was director of the Managers' Conference at Jacob's Pillow. A graduate of Wesleyan University, Mr. Miller currently lives in Litchfield, Connecticut.

Robert L. Olson is a senior associate with the Institute for Alternative Futures. He currently directs the institute's project with the Information Industry Association on the information business of the future. His major interests are centered on strategic thinking in private and public organizations and on the social impacts of technological change. He formerly worked as a project director and consultant to the director at the Office of Technology Assessment of the U.S. Congress, and as a policy analyst with the National Academy of Science. Mr. Olson's background is in political science. He has taught at the University of Michigan and the University of Illinois, and he continues to do occasional teaching. Recent teaching experience includes graduate seminars on "alternative global futures" at American University's School of International Service and graduate seminars on government foresight for federal employees through the University of Southern California's Washington Public Affairs Center.

Charles V. Raymond joined the New York City Ballet as managing director in 1985. A graduate of Syracuse University, he has worked with New York City's Human Resource Administration, served as director of several special projects committees formed under the administration of Mayor John V. Lindsay, and was deputy administrator of the New York State Division of Criminal Justice Services. Mr. Raymond served as deputy director for development of the Center for Policy Research of Columbia University, deputy commissioner for management services for the New York State Department of Mental Health, and deputy commissioner of the Department of Housing of the City of New York. Before becoming managing director for New York City Ballet, Mr. Raymond served as president of CEA Combustion, Inc., and as president and chief executive officer of Todd Combustion, Inc.

A. B. Spellman has been director of the Expansion Arts Program of the National Endowment for the Arts since 1978. In this post he is responsible for programs aimed at advancing the development of community arts organizations. He has been with the NEA since 1976, first serving as assistant director of the Expansion Arts Program. He also helped establish the Endowment's division of civil rights. He was named head of Expansion Arts in 1978. Prior to joining the NEA, Mr. Spellman contributed to the arts world as author, poet, critic, and lecturer. He was an artist-in-residence at Moorehouse College and has taught courses in jazz at Emory, Rutgers, and Harvard Universities and has been a television and radio commentator. He also serves as an advisor on arts boards and panels of the Smithsonian Institution, the NEA, and National Education Television. Mr. Spellman completed his academic work at Howard University in Washington, D.C.

Mike Steele has been a drama and dance critic for the *Minneapolis Star & Tribune* since 1966. He has also written for various other theatre, visual arts, and music journals. Mr. Steele is a member of the executive committee for the American Theatre Critics Association and formerly served on the National Endowment for the Arts Dance Advisory Panel.

George Thorn divides his time between being an arts management consultant and co-directing the Arts Management Institute at Virginia Polytechnic Institute and State University

in Blacksburg, Virginia. Prior to these activities, he was the fiscal and administrative officer of the Eugene O'Neill Theatre Center. Mr. Thorn spent sixteen years in New York where he was a stage manager for eight years. While in New York, Mr. Thorn had a private general management firm which managed Broadway, Off-Broadway, and touring companies. Mr. Thorn was the co-director of FEDAPT's 1985 National Conference on Leadership and Partnership.

Jerry Yoshitomi is executive director of the Japanese American Cultural and Community Center in Los Angeles. His previous experience includes vice president and director of operations for the Western States Arts Foundation and deputy director of the Arizona Commission on the Arts and Humanities. He currently serves, or has served, on numerous boards, panels, and committees, and has published and made presentations on a variety of topics in the arts.

BIBLIOGRAPHY

Adams, James L. *Conceptual Blockbusting*. New York: W.W. Norton & Co., 1974.

Asimov, Isaac; Lodge, George C.; Yankelovich, Daniel; et al. *Work in the 21st Century*. Alexandria, VA: ASPA, 1984.

Bennis, Warren, and Nanus, Burt. *Leaders: The Strategies for Taking Charge*. New York: Harper & Row, 1985.

Ferguson, Marilyn. *The Aquarian Conspiracy*. Los Angeles: J. P. Tarcher, 1980.

Leonard, George B. *The Transformation*. 2d rev. ed. Los Angeles: J. P. Tarcher, 1981.

Leone, Robert A. *Who Profits: Winners and Losers and Government Regulations*. New York: Basic Books, 1986.

Louv, Richard. *America II*. New York: Penguin Books, 1983.

Naisbitt, John. *Megatrends*. New York: Warner Books, 1982.

Naisbitt, John, and Aburdene, Patricia. *Re-inventing the Corporation*. New York: Warner Books, 1985.

Polak, Fred. *The Image of the Future*. San Francisco: Jossey-Bass, 1973.

Ries, Al, and Trout, Jack. *Positioning, the Battle for Your Mind*. 2d rev. ed. New York: McGraw-Hill, 1986.

Thompson, William Irwin. *Pacific Shift*. San Francisco: Sierra Club Books, 1985.

Toffler, Alvin. *The Third Wave*. New York: Bantam Books, 1980.

Toffler, Alvin. *Previews & Premises*. New York: Bantam Books, 1983.

Toffler, Alvin. *The Adaptive Corporation*. New York: Bantam Books, 1985.

Yankelovich, Daniel. *New Rules: Searching for Self-Fulfillment in a World Turned Upside Down*. New York: Bantam Books, 1981.